Virtual Pose® 3

The Ultimate Visual Reference Series
for Drawing the Human Figure

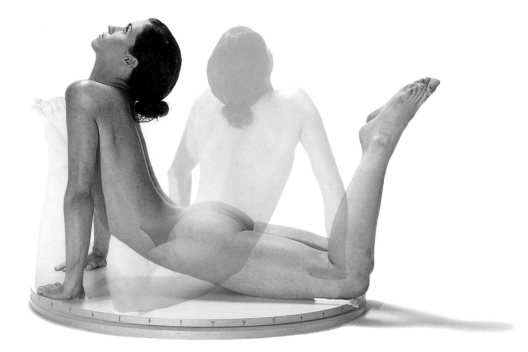

Published by
HAND BOOKS PRESS, GLOUCESTER, MASSACHUSETTS

Distributed by
NORTH LIGHT BOOKS, CINCINNATI, OHIO

Mario Henri Chakkour
Photography by Missy Loewe
CD-ROM produced by Gregory Scott Wills

MAC/PC CD-ROM
ENCLOSED

VIRTUAL POSE® 3
The Ultimate Visual Reference Series for Drawing the Human Figure

by Mario Henri Chakkour

Copyright © 2004 by Hand Books Press

Used under exclusive license from
StudioView Interactive, LLC
P.O. Box 20052, Alexandria, VA 22320

Published by
Hand Books Press
86 Eastern Point Blvd., Gloucester, MA 01930
handbooks@adelphia.net

Distributed by
North Light Books, an imprint of F+W Publications, Inc.
4700 East Galbraith Road, Cincinnati, Ohio 45236
TEL 800-289-0963

Creative Direction: Mario Henri Chakkour
Art Direction: Stephen Bridges
Design: Beth Santos
Photography: Missy Loewe
Female Models: Yulia Eyman, Natasha Grandon, Angelique Kithos, Candace Nirvana
Male Models: Ted Culp, Iavor Ivanov
CD-ROM Produced by Gregory Scott Wills

The sculpture and words of Mr. Al Solomon were used with the artist's permission. Copyright © 2003 by A. A. Solomon.
Photography for the Prologue section courtesy of Greg Gissler and Timb Hamilton.

Visit us on the Web at www.virtualpose.net

ISBN 10: 0-9714010-4-7
ISBN 13: 978-0-9714010-4-4

09 08 07 06 6 5 4

Printed in China

Table of Contents

Introduction
page iv

Prologue
page vi

How to Use this CD
page viii

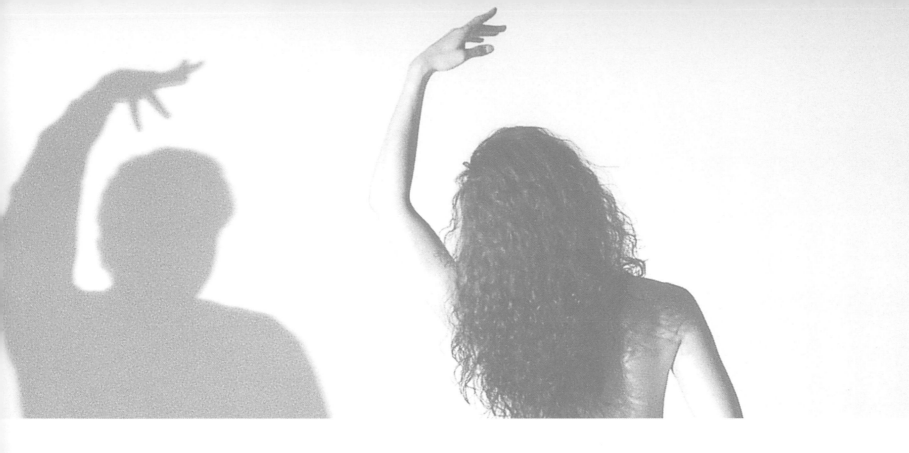

Introduction

MARIO HENRI CHAKKOUR

Like practicing the scales, paying homage to the perfect creation requires diligence and humility. And if seven notes can produce infinite musical variations, imagine what a nude figure can do! Furthermore, faced with such possibilities, the artist is bound to feel overwhelmed. What a small price to pay for glimpsing a world many have known only from books and myth.

Indeed, there is a special kind of magic that takes place each time a model adorns a pose, prompting the sculptor to reduce the stone with a hammer and chisel, or the painter to fill the canvas with pigment. And if model and artist share a similar vision, a silent rhapsody emerges, underscoring the primal need to partake in this ancient ritual celebrating the human figure.

Growing up on Phoenicia Street, the epicenter of Beirut's entertainment district, helped mold my perception and appreciation of the human form. On this peninsula cradled by the Mediterranean Sea, grew the seeds of inspiration, prompted mainly by the row of night clubs whose marquees featured exquisite photography of dancers and models in poses that evoked a world unlike anything I've seen since. And a couple of blocks to the north, I was privileged to see up close how artists interpreted the figure in a mansion housing what would later become the Dahesh Museum in New York City — the only museum devoted to 19th & 20th century European academic art. Accordingly, until I experienced first hand my initial life drawing session, I always wondered, "what's wrong with drawing from a picture in a book?" I can't explain it, but faced with a real model, my drawing matured. It reflected a truth and humanity no mere photographic or painted reference alone could inspire.

Today, I maintain that nothing can replace a real model. However, empowered with real-life experience, a visual reference series such as Virtual Pose provides us with a more technical understanding about the human figure — since it allows us to rotate the figure at will. For one thing, not everyone can afford the luxury of live models, let alone their ability to pose hours at a stretch!

In the first two editions, the inclusion of music and tutorial movies attempted to recreate the magic we've all experienced in a life drawing studio. And, to the uninitiated, it became a catalyst for participation. However, Virtual Pose and its loyal following, began to experience growing pains. Many expressed a desire for more poses, in color, and in high resolution. And so we come to a decisive crossroads, culminating in Virtual Pose 3, fully confident you will find it the best we've shown to date. Models and assistants worked in concert under Missy Loewe's masterful eye and direction creating a wonderful atmosphere that shines through the superb poses featured in this edition.

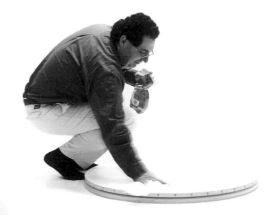

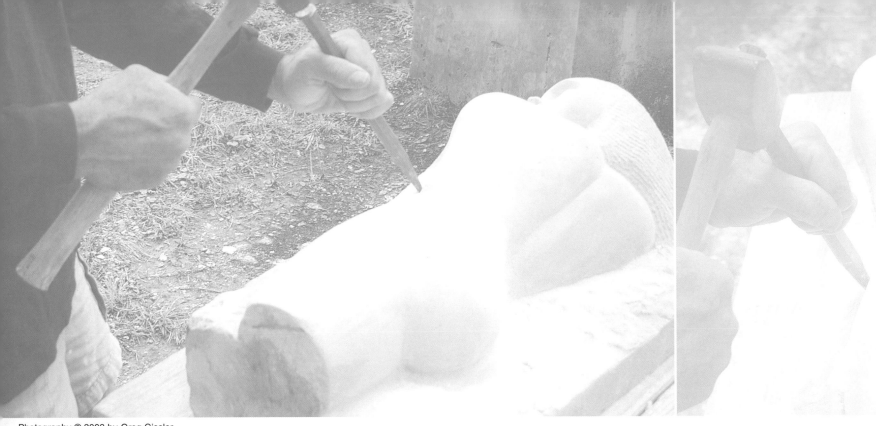

Prologue
AL SOLOMON

Stones have spirits. If you listen they tell you what wonders they have seen, what lessons they have learned. The stone has waited countless centuries to show the world the beauty hidden within. Like a surfer riding a wave, I never fight the stone. I allow the flow of the stone to guide me. I never remove any more material than the stone wants me to.

Form and function are nature's greatest relationships. They transcend time and survive evolution. That beauty is the result of proportion, is both visually obvious, and mathematically calculable. Nowhere are form, function, and proportion more beautifully exhibited than in the human form.

It is said that beauty is truth. Truth is usually simple when we understand it. To get to the truth in life often requires removing layers of fear, ignorance, hatred, etc. Working in stone is an analogy for finding truth in life. We remove until we reveal.

human form

sculpture

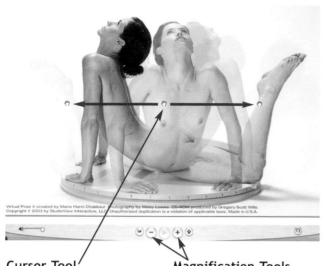

Virtual Pose © created by Mario Henri Chakkour. Photography by Missy Loewe. CD-ROM produced by Gregory Scott Wills. Copyright © 2003 by StudioView Interactive, LLC. Unauthorized duplication is a violation of applicable laws. Made in U.S.A.

Cursor Tool
Cursor turns to hand once positioned over pose. Click and Drag to the left or right to rotate.

(If using a tablet and digitizing pen, press the nib on the surface of the tablet and drag left or right).

Magnification Tools
To enlarge the size of the pose, click on the icon with the "**+**" sign.

To reduce the size of the pose, click on the icon with the "**-**" sign.

MAC/WINDOWS
The Virtual Pose® 3 Companion CD-ROM located inside the back cover features 70 high resolution QuickTime VR (QTVR) poses (with 36 views each) you can play individually in the QuickTime (QT) Movie Player (provided), thus offering 2,520 total views to view and print!

LOCATING A POSE
Browse the book to locate a pose, note its page number (Page 1, 2, 3 etc..), and locate it on the CD-ROM in "PosesFolder" by matching the pose number to that of the page number. Please note there are 7 folders inside "PosesFolder" (we thought it more convenient for you to group the poses in sets of 10). Therefore, the pose on page 1 of the book would correspond to file "01" (or "01.mov") on the CD-ROM.

LAUNCHING A POSE
Once the desired pose file is located, double click to launch it in QuickTime Movie Player. Then, resize it (reduce) to fit your screen (or increase your screen resolution to its maximum display ability), rotate the pose, and work directly from the screen or print at will from within QT Movie Player.

ROTATING THE POSE
To rotate the model, simply position the cursor in the middle of the QT Movie Player window, click the mouse and drag to the left or to the right. If using a tablet and digitizing pen, press the nib on the surface of the tablet and drag the left or the right.

RESIZING/NAVIGATING AFTER ZOOMING
Due to the size of the poses, you might need to reset your monitor to the highest possible resolution OR resize the Movie to fit your screen. Ideally, you would view the poses at 100% (NORMAL SIZE). QT Movie Player offers several options to control the Movie window size. Most PC users will soon find that Windows won't allow them to drag the QuickTime movie window vertically beyond a certain point, and thus will not see the movie controls that can be easily substituted with keyboard commands.

KEYBOARD COMMANDS:

MAC

To **ZOOM IN** (Increase Magnification):
Press the SHIFT key.

To **ZOOM OUT** (Reduce Magnification):
Press the CONTROL key.

To **DRAG** image (in ZOOM mode):
Press the OPTION key, and drag with the mouse/tablet.

To **FIT TO SCREEN**:
Press the COMMAND+3 keys.

PC

To **ZOOM IN** (Increase Magnification):
Press the SHIFT key.

To **ZOOM OUT** (Reduce Magnification):
Press the CONTROL key.

To **DRAG** image (in ZOOM mode):
Press the CONTROL+ALT keys, drag with the mouse/tablet.

To **FIT TO SCREEN**:
Press the CTRL+3 keys.

Recommended System Requirements:

The Virtual Pose® 3 CD-ROM features QuickTime (QT) 6.0.3 for OS8/9; QT 6.3 for OSX and Windows. If the user chooses to upgrade to QT 6.x then the recommended system requirements are:

MAC: A 400 MHz PowerPC G3 or faster Macintosh computer. At least 128MB of RAM. Mac OS 8.6 or Mac OS 9.x. (QT 6.0.3), and Mac OS X v10.1.5; v10.2.3 or later (QT 6.3).

PC: A Pentium processor-based PC or compatible computer. At least 128MB of RAM. Windows 98/Me/2000/XP.

QT Pro Users Please Read: Installing the included QT 6 player will remove any previous version of QT that may have been installed. This will also invalidate your (OPTIONAL) old QT Pro Key and require that you purchase a new QT 6.x Pro Key to maintain your existing "Pro-Level" capabilities. YOU MAY NOT WANT or NEED TO DO THAT... the older version of QT may work "just fine" with the poses contained in VP3. Therefore, before you upgrade (and potentially lose your QT PRO Key privileges, should you happen to own one) we recommend that you double click a pose and take it for a test-drive. You may also want to check the Apple Computer Company, Inc. Quicktime site (http://www.apple.com/quicktime/download) to see if there is an even newer version available than the QT 6 shipped with VP3.

Produced by StudioView Interactive, LLC.

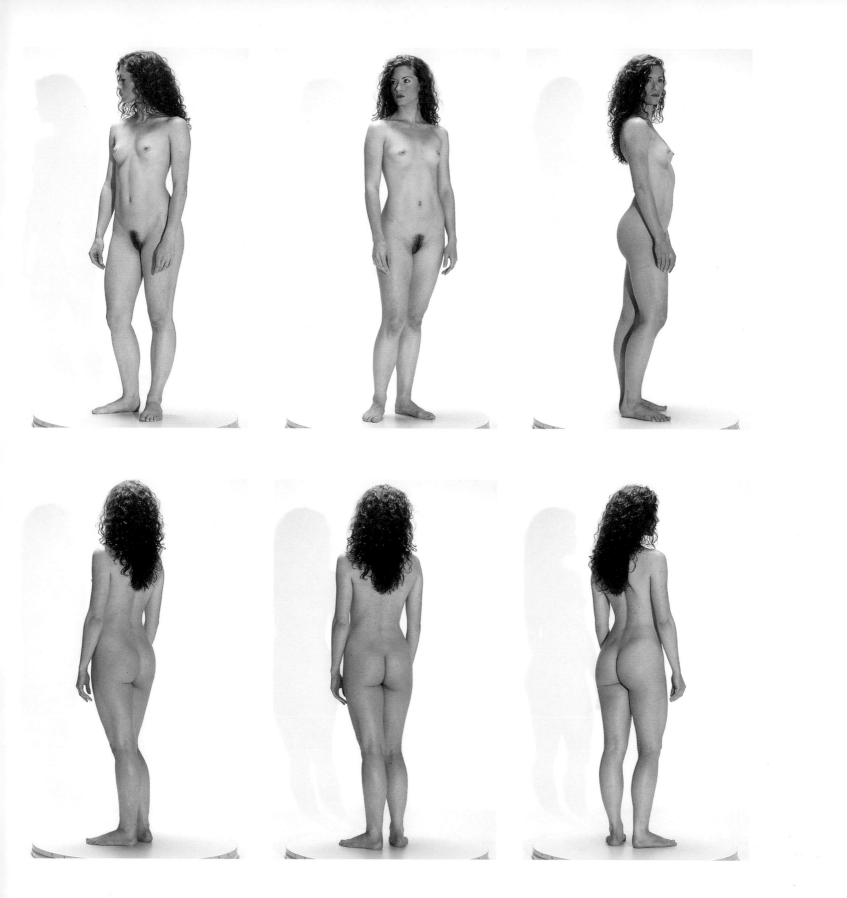

Female Pose 1

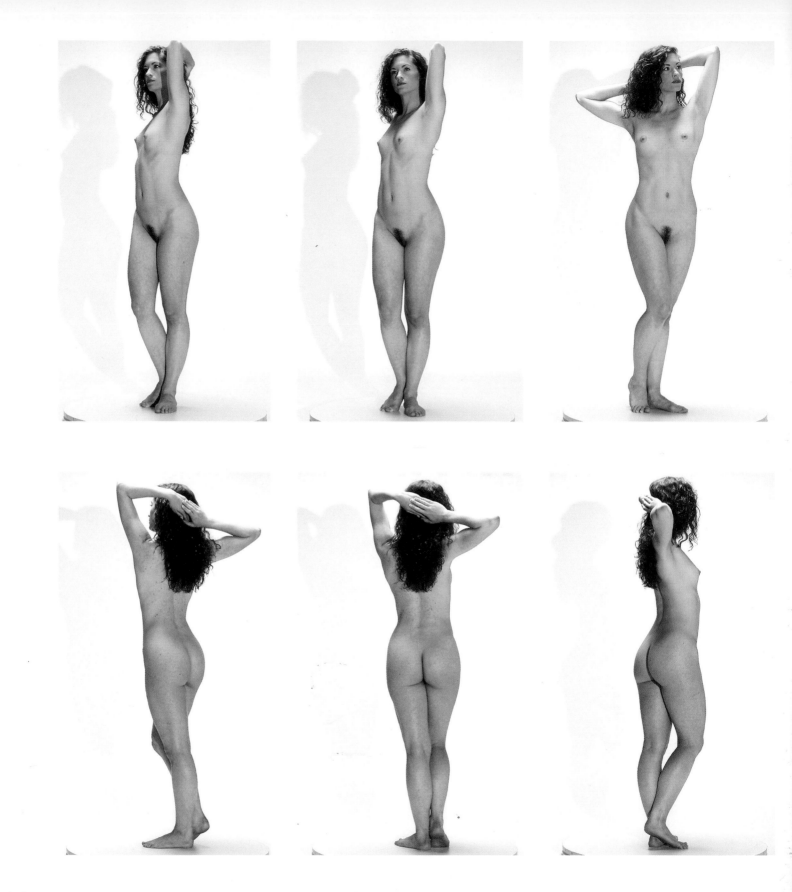

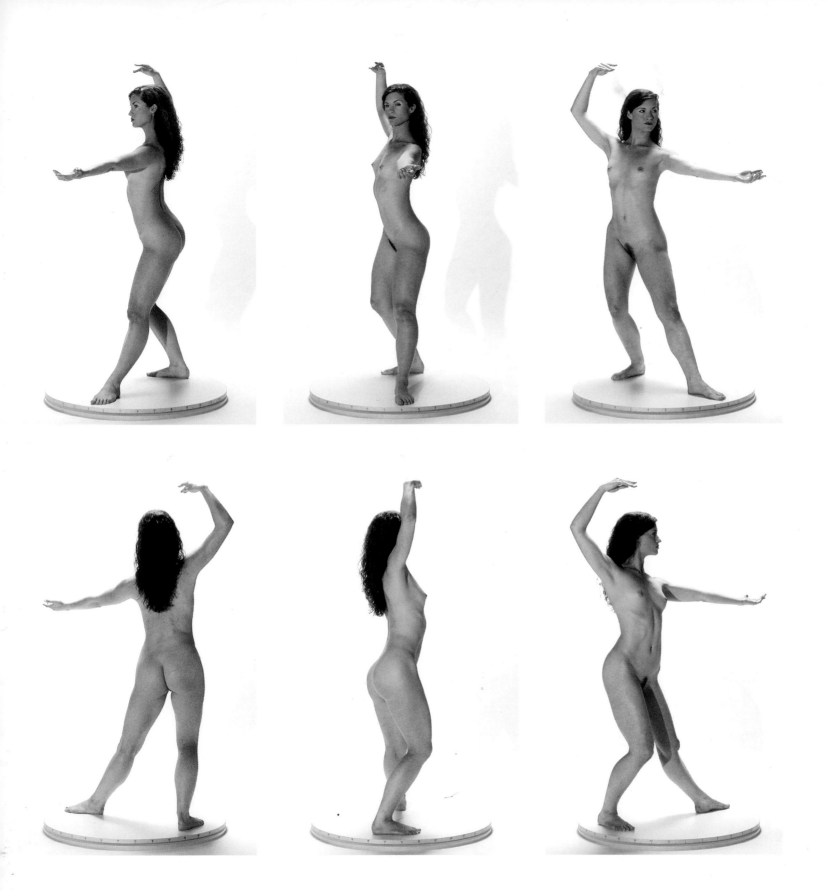

Female Pose 3

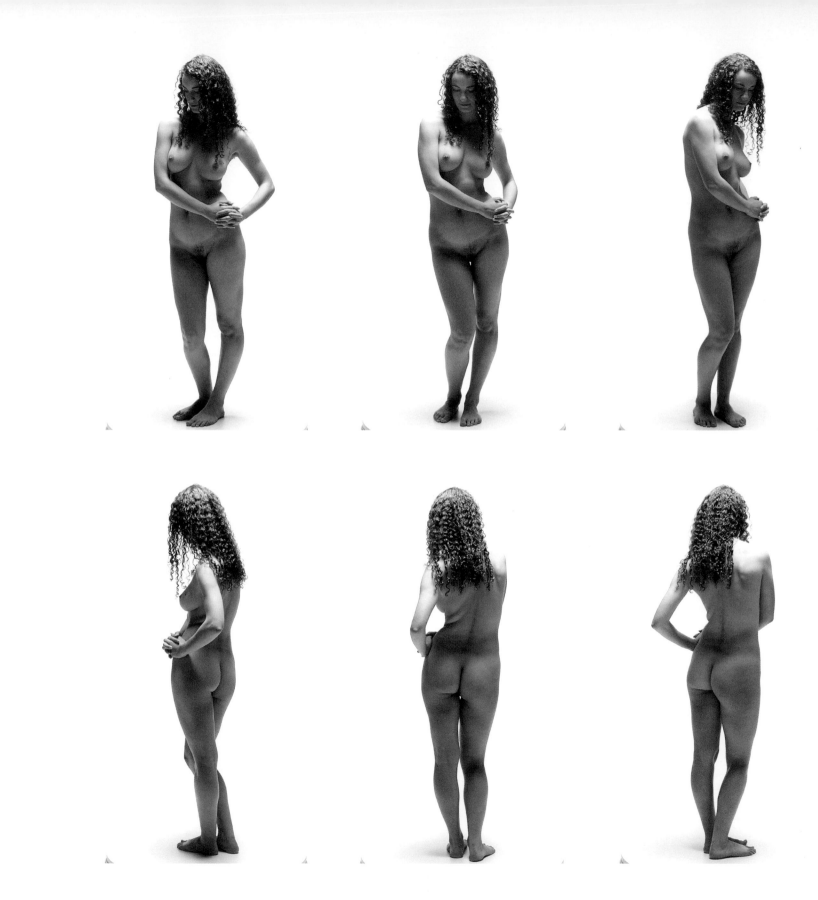

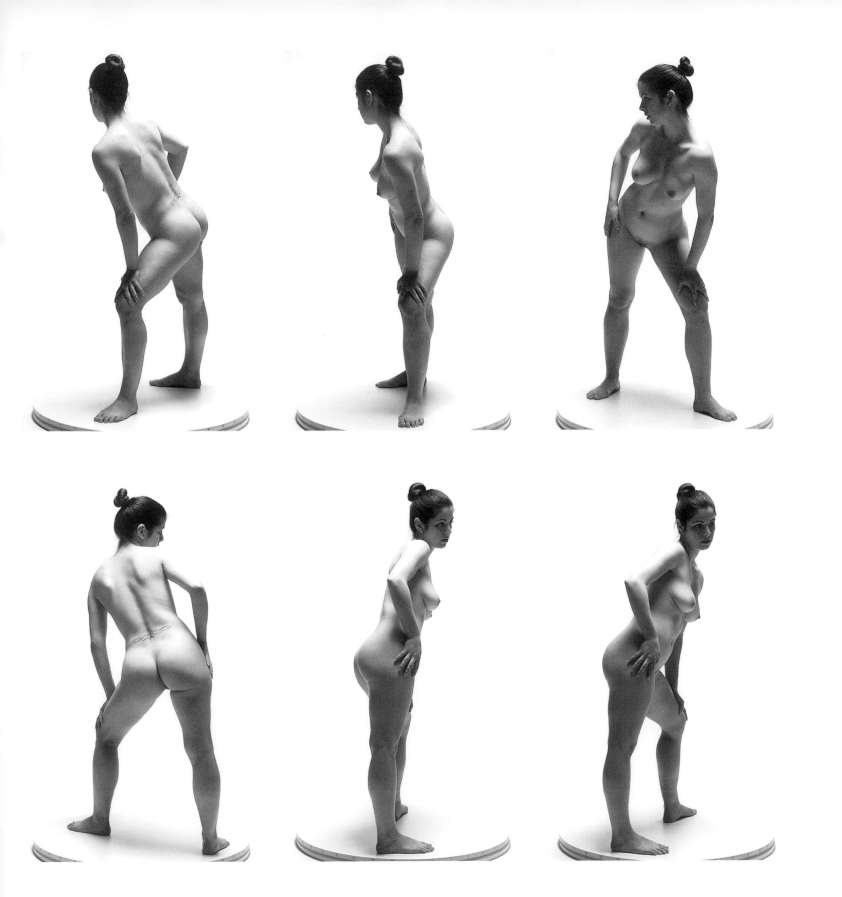

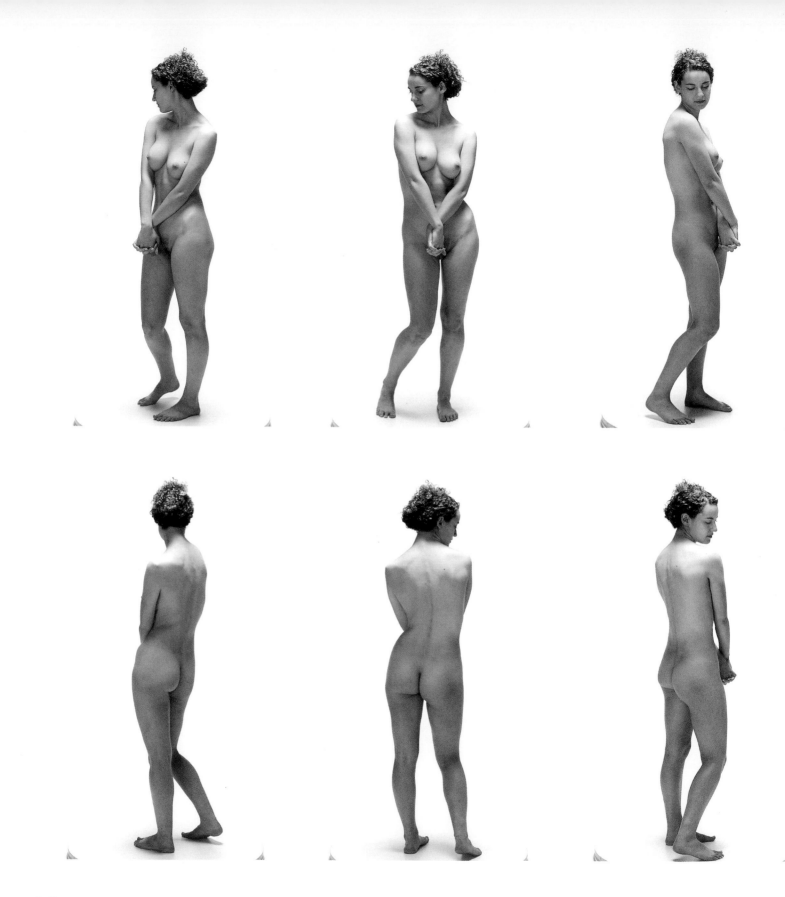

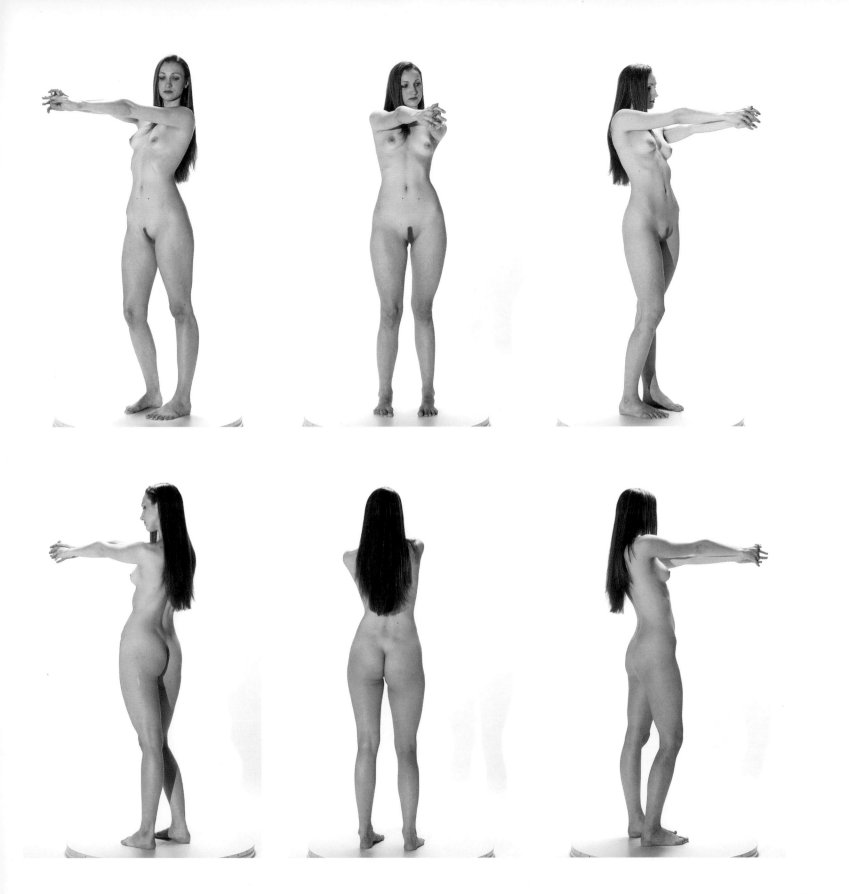

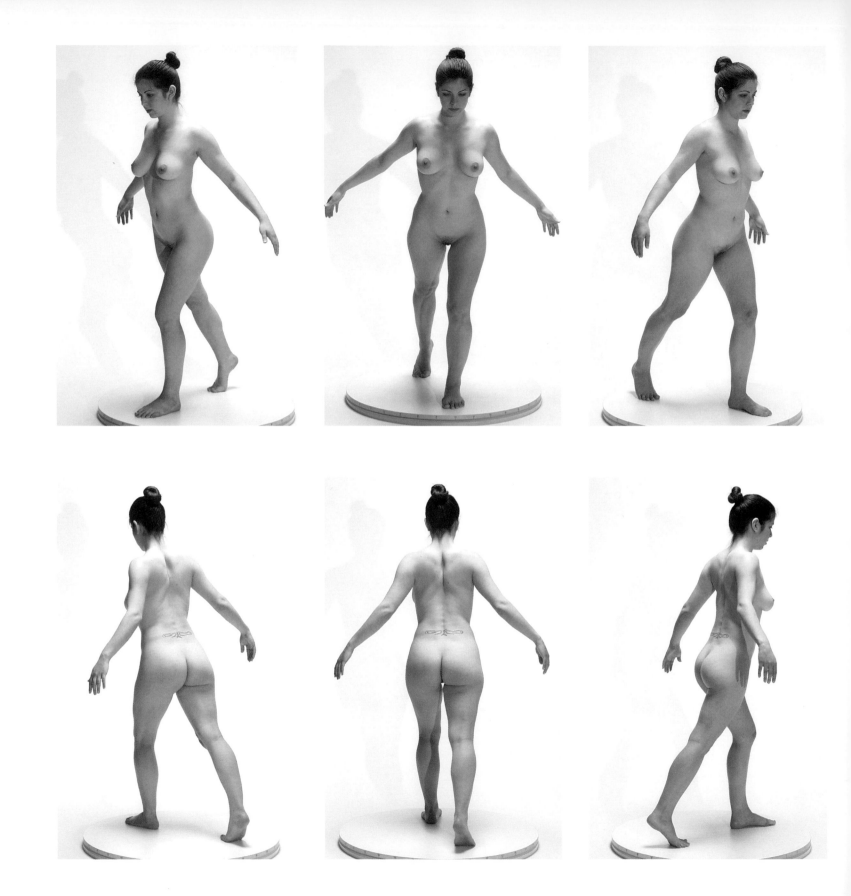

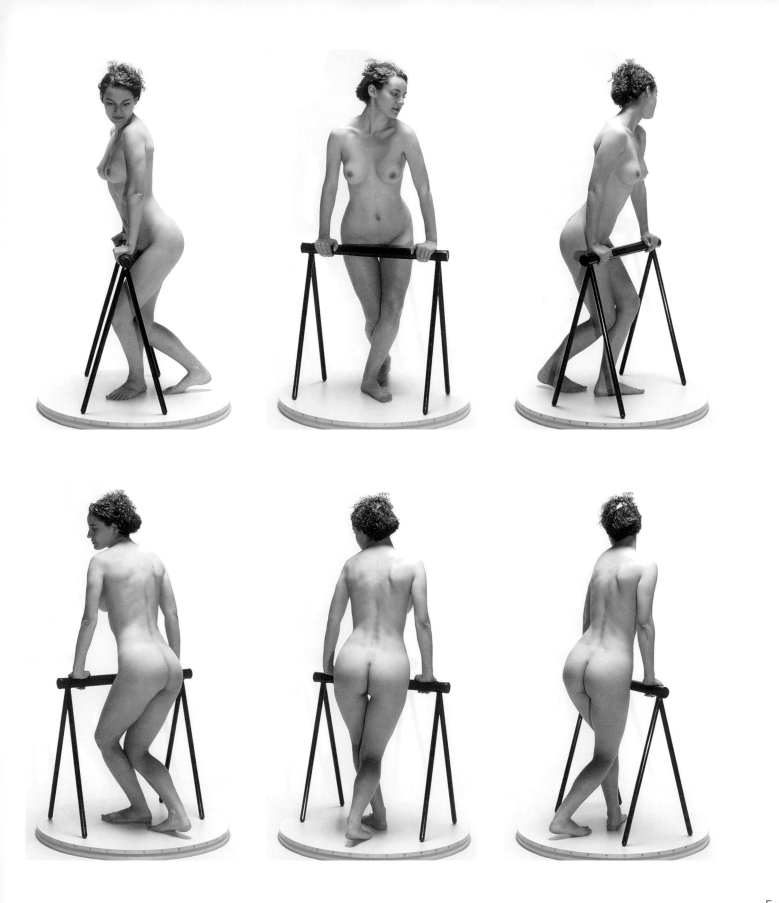

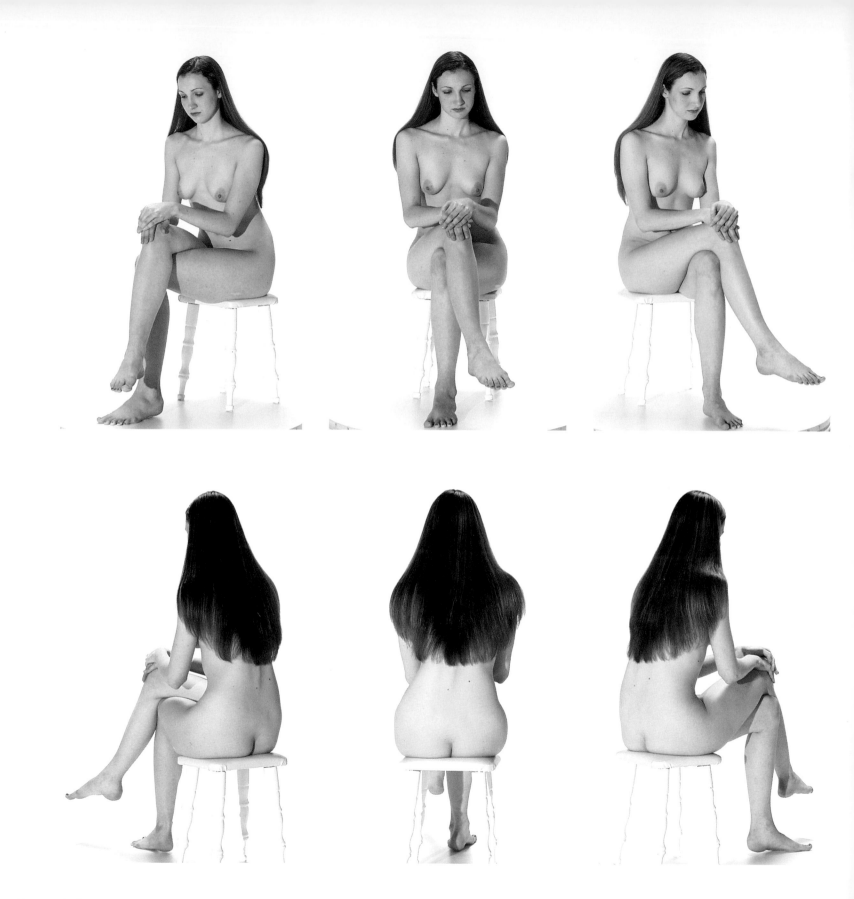

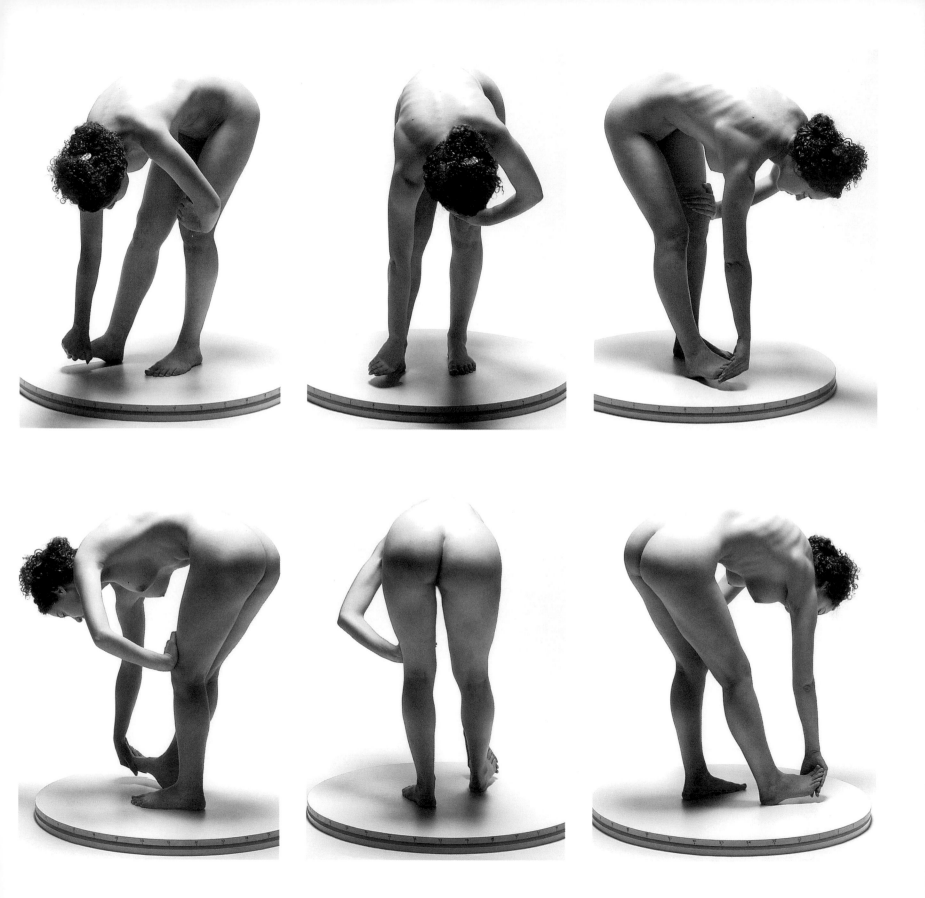

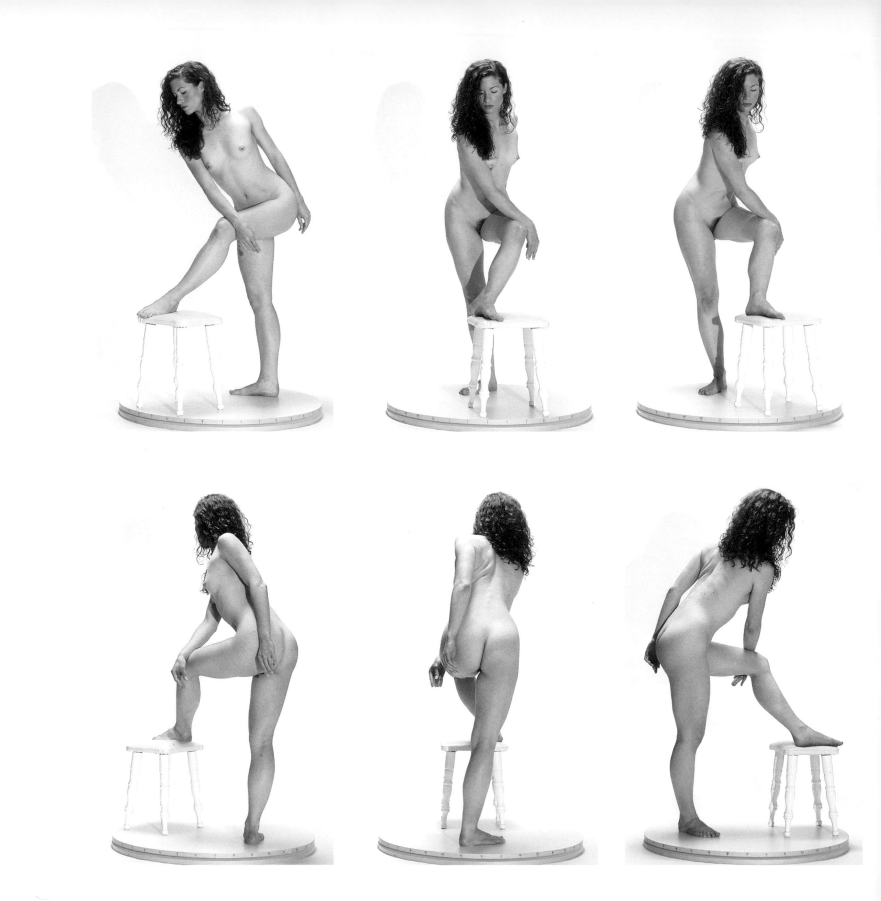

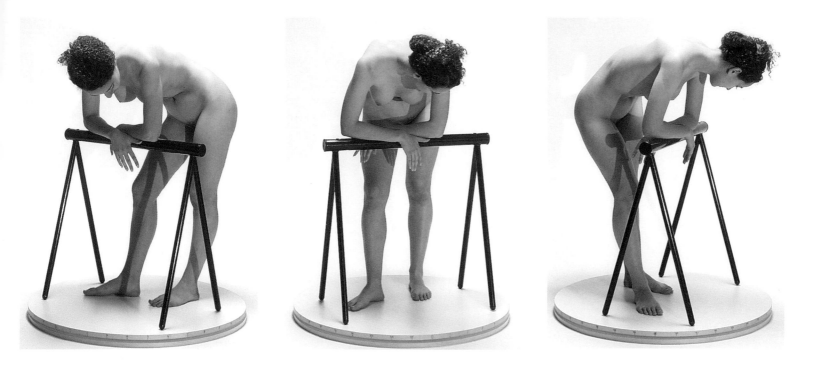

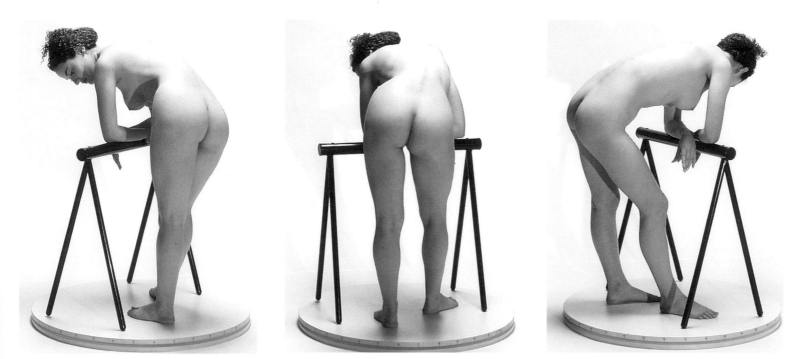

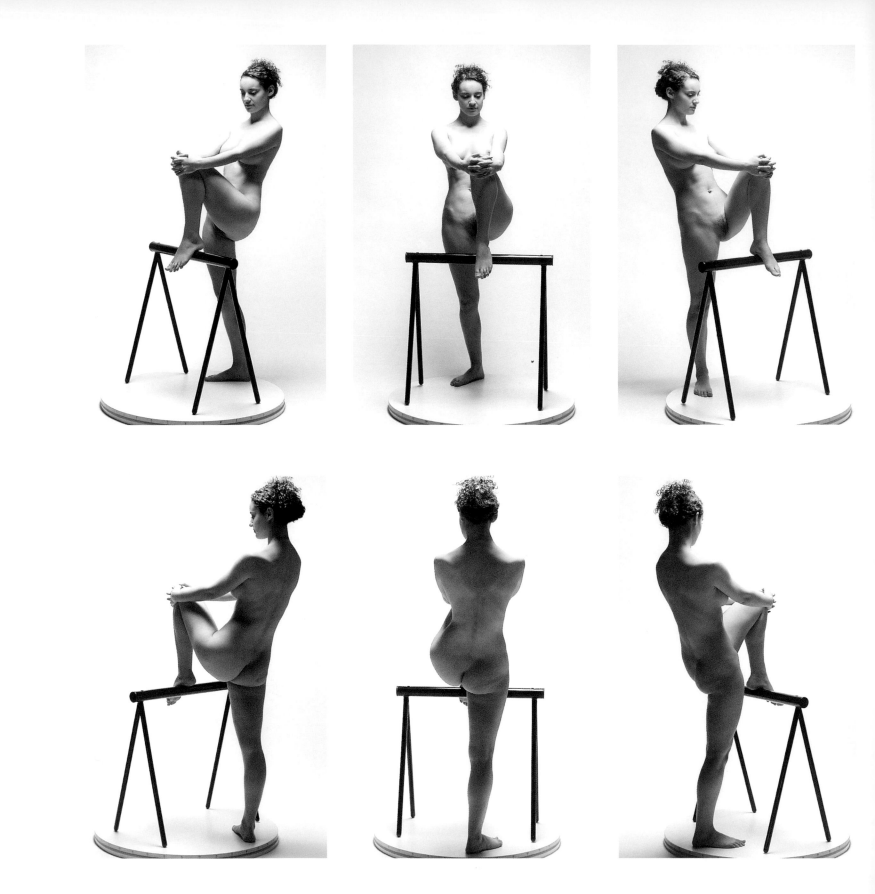

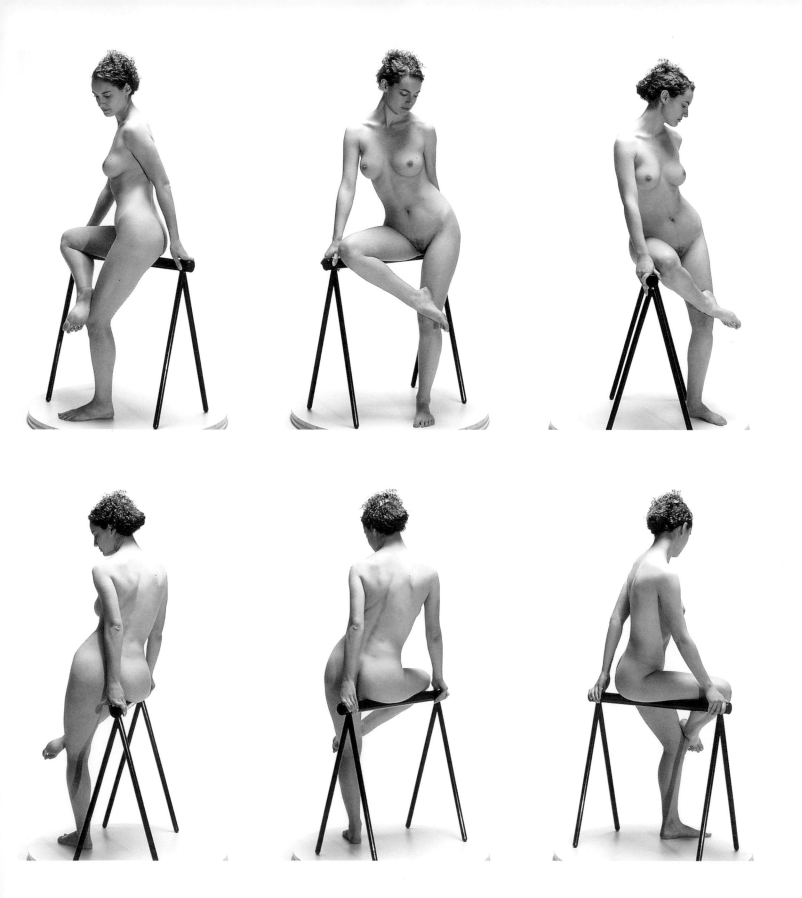

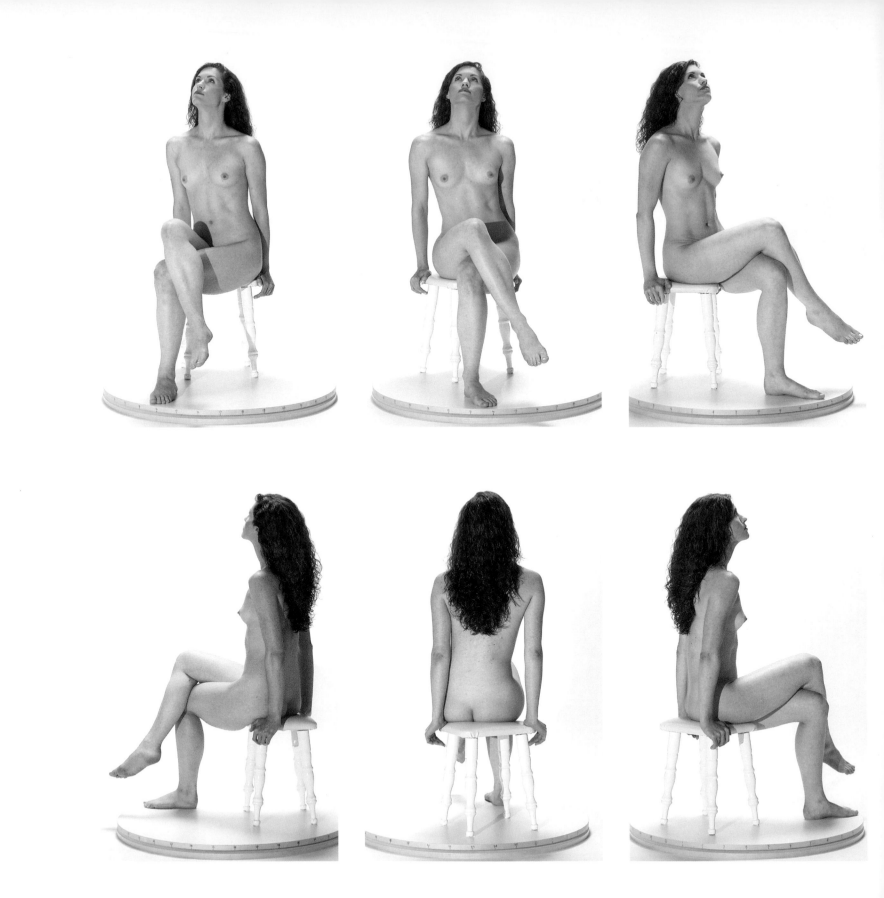

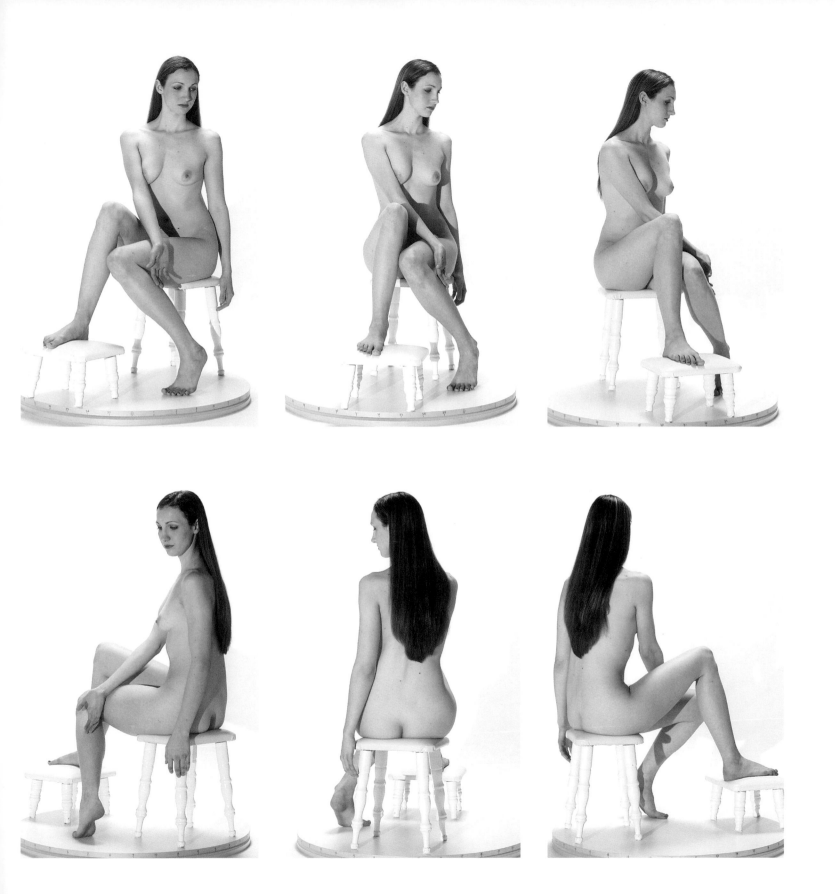

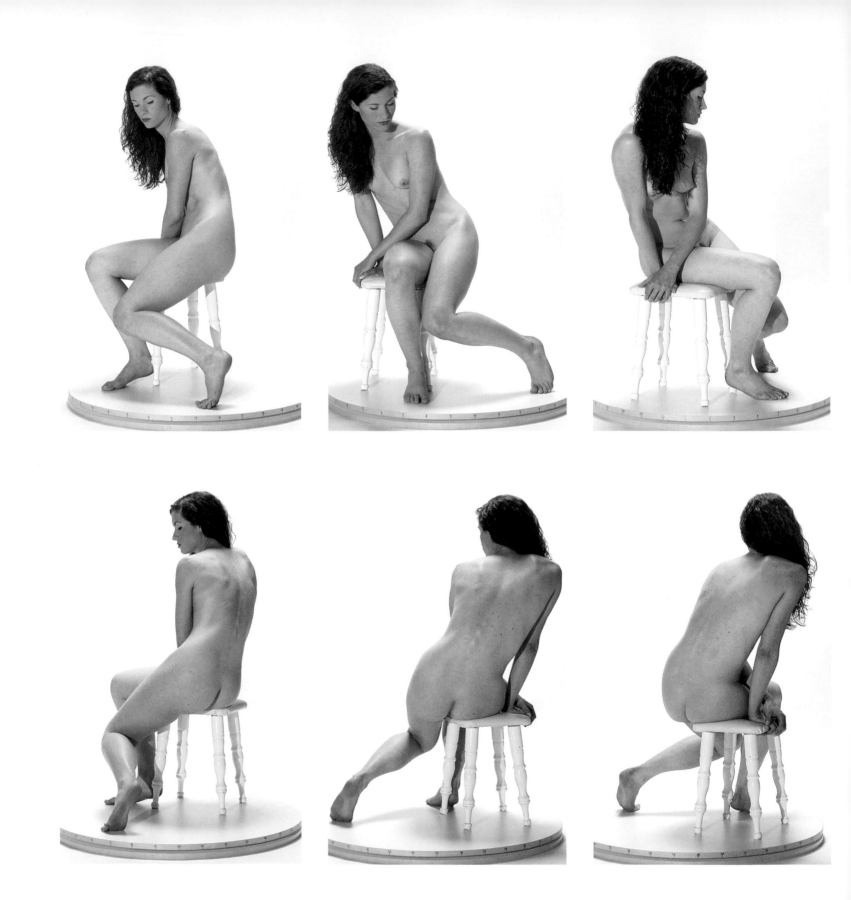

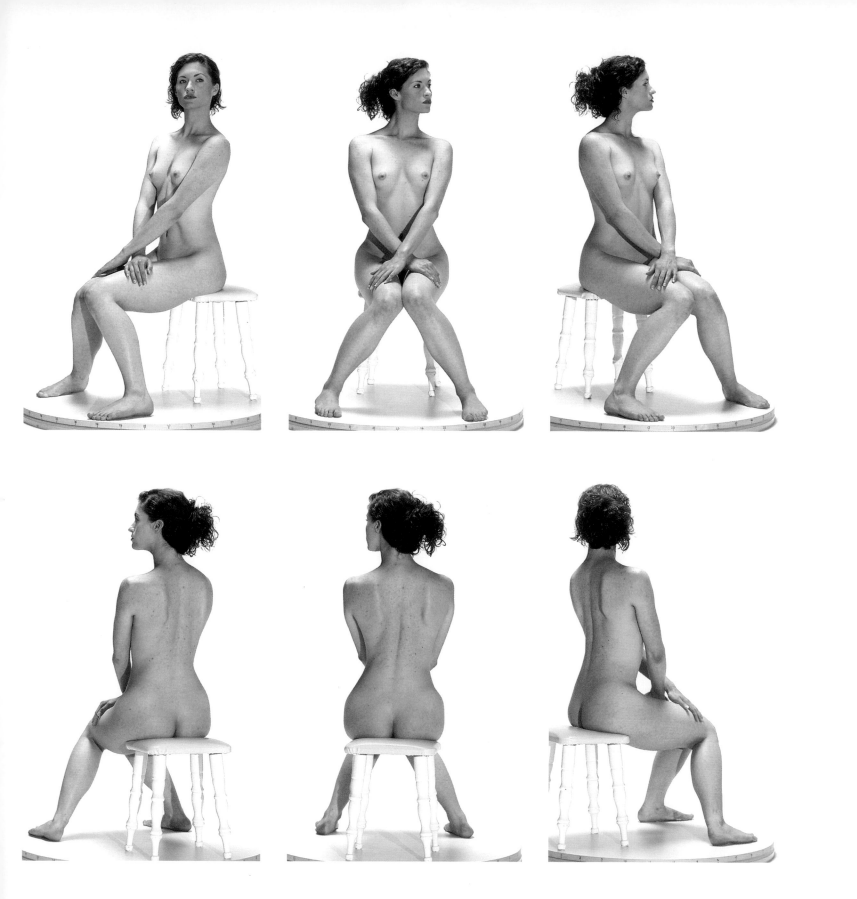

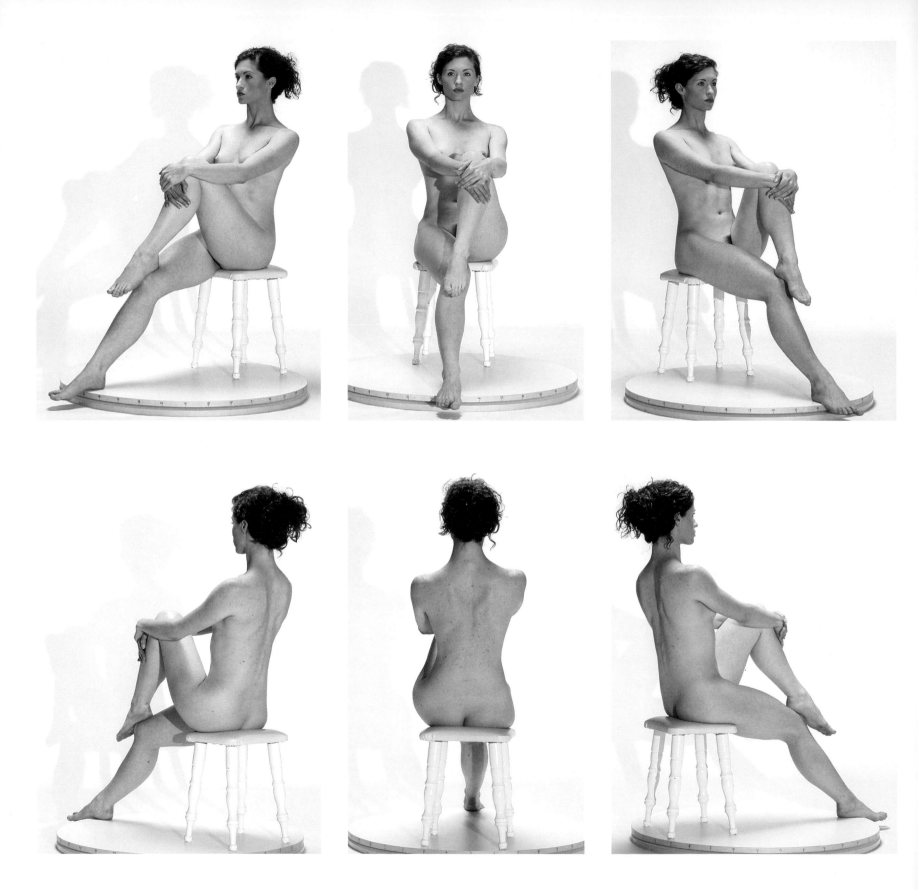

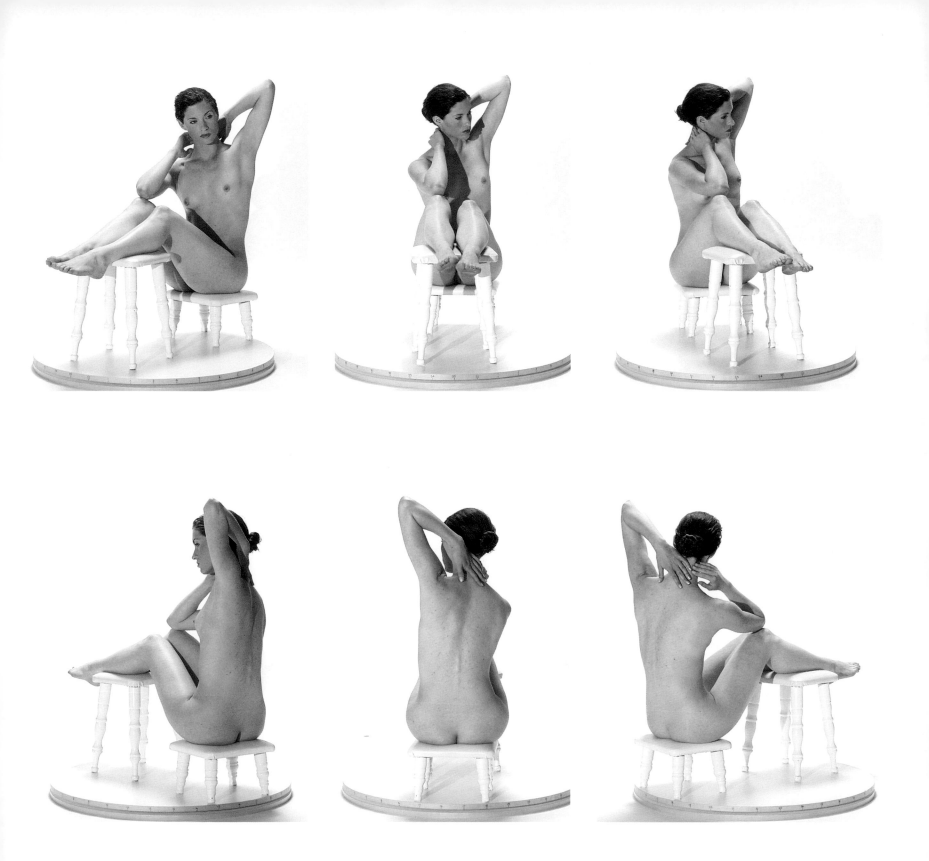

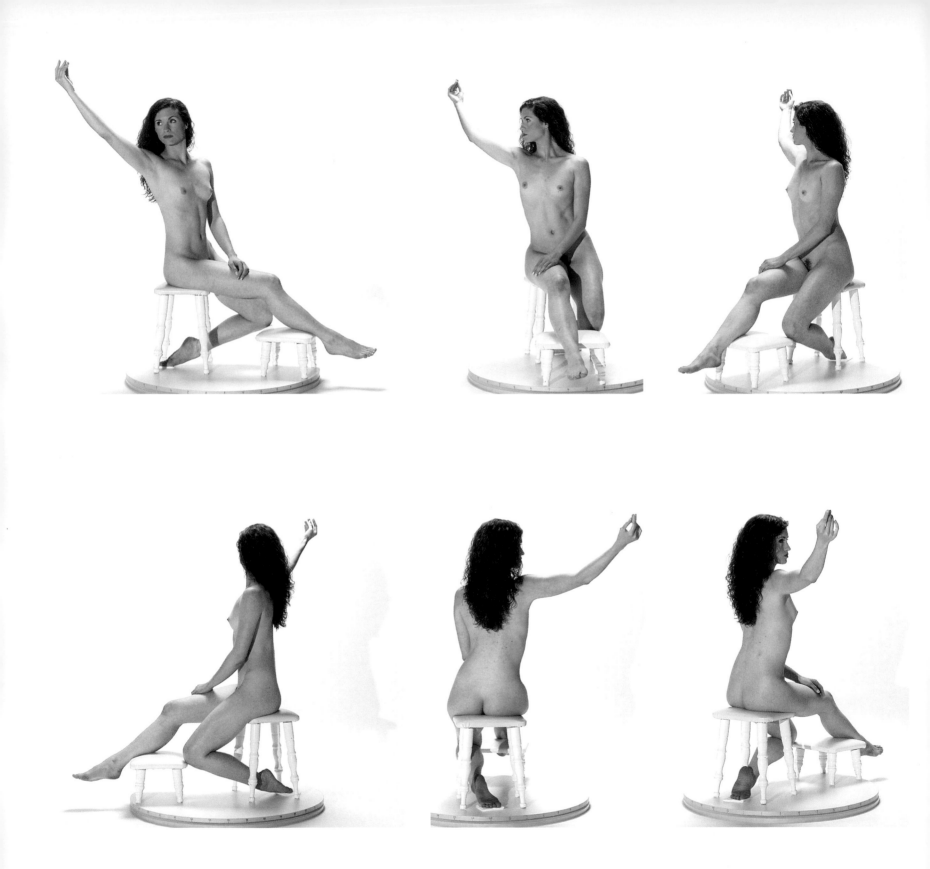

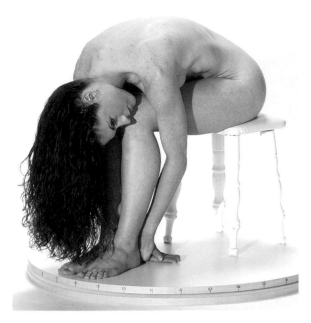
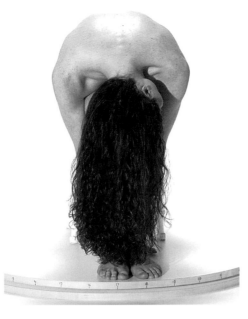
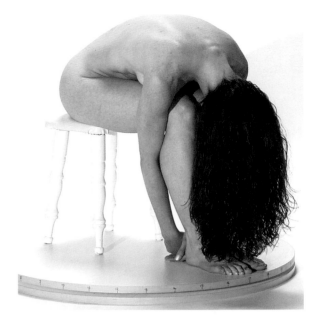
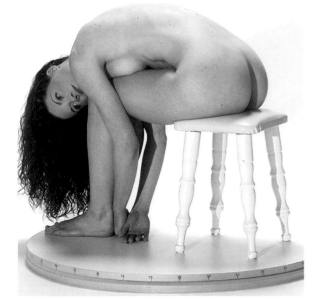
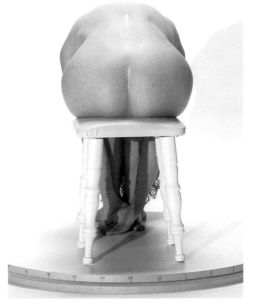
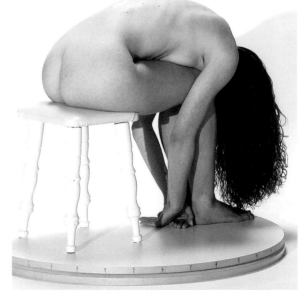

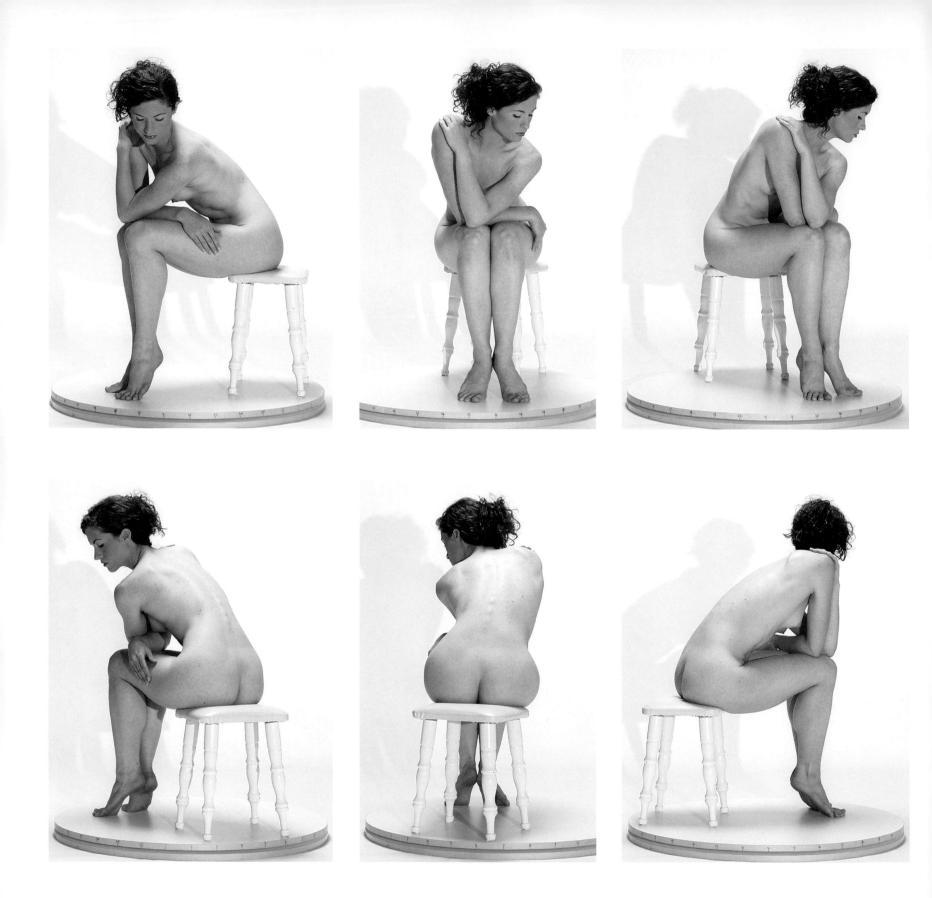

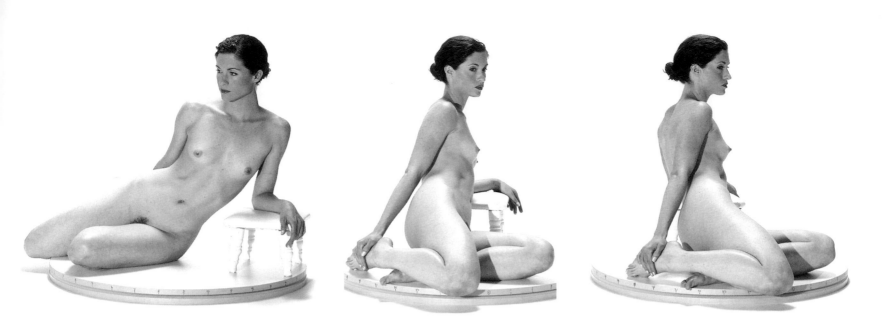

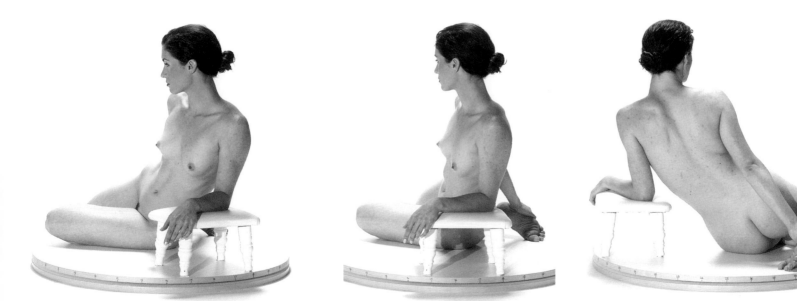

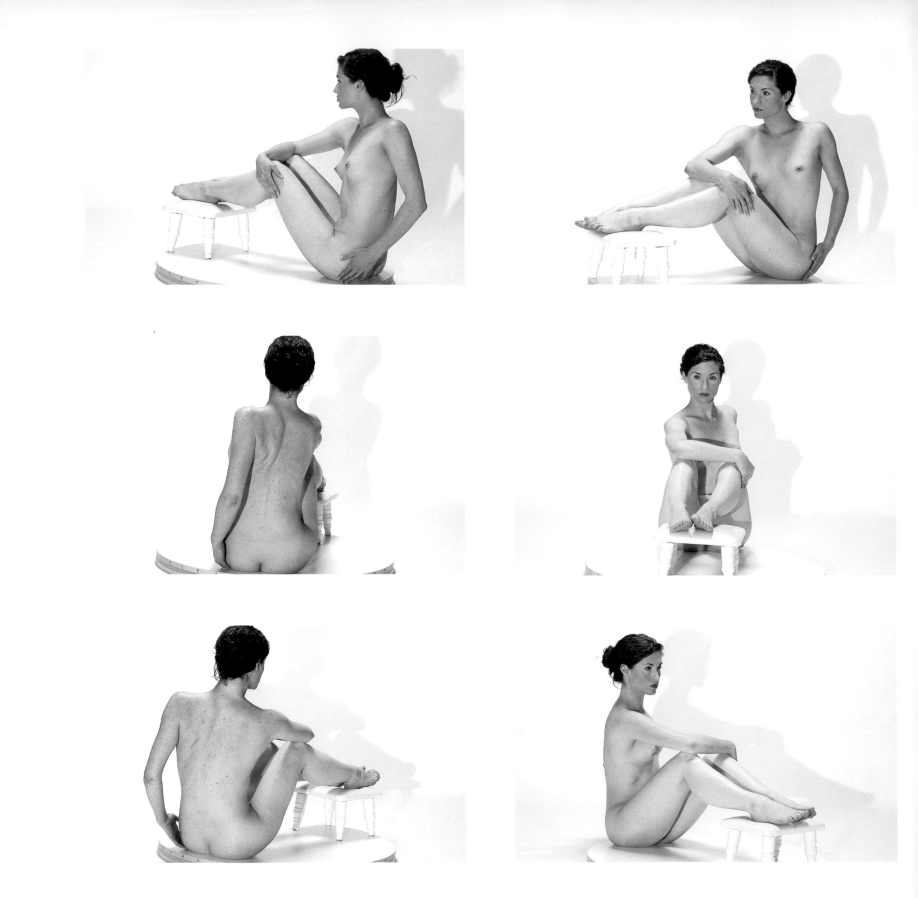

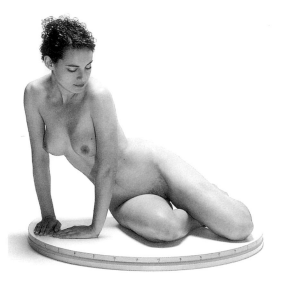
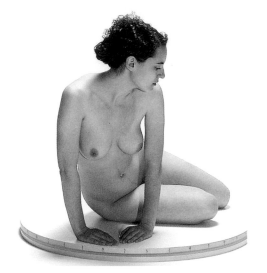
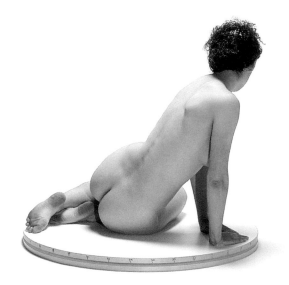
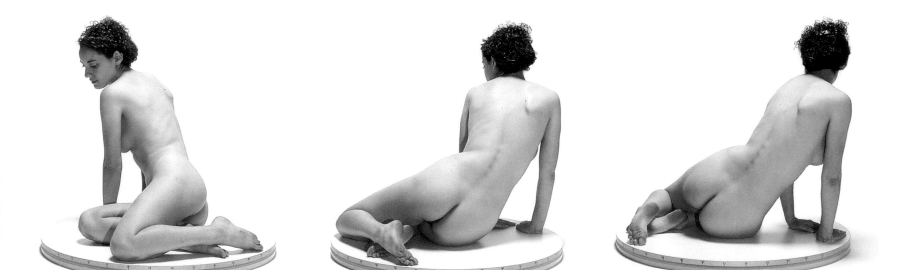

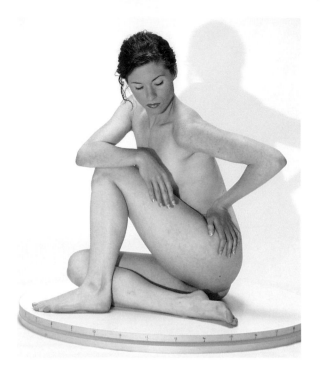
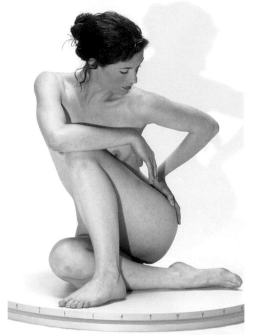
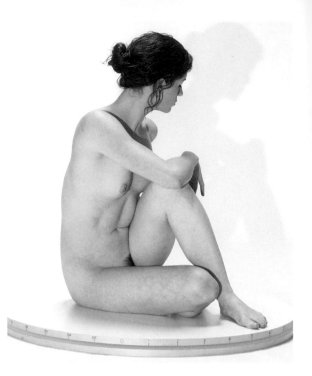
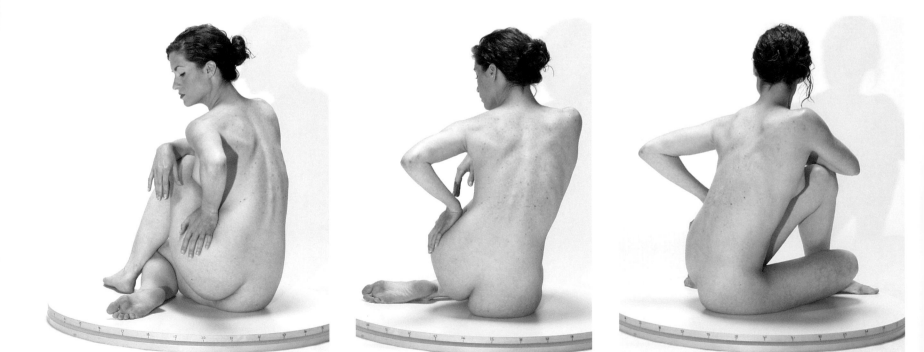

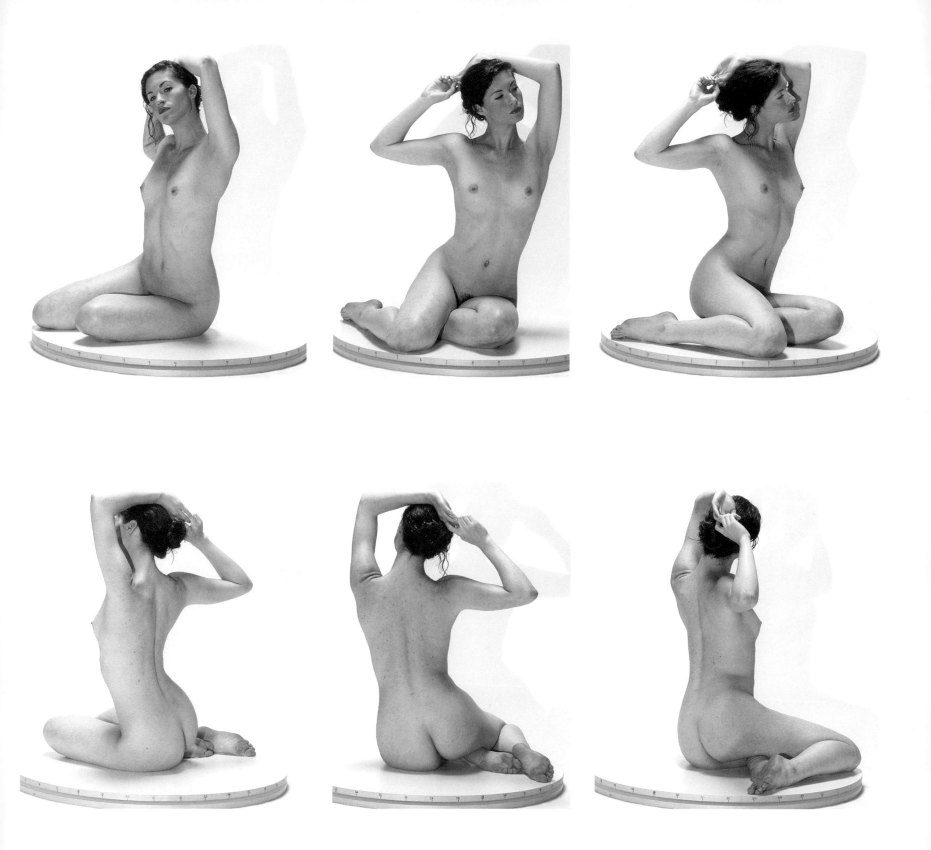

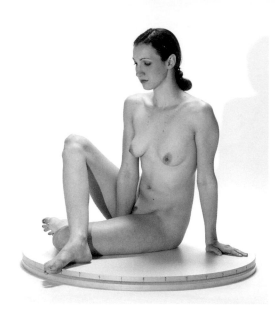
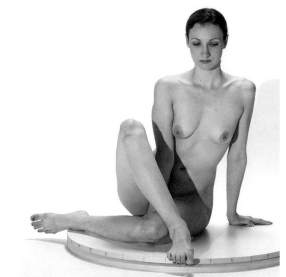
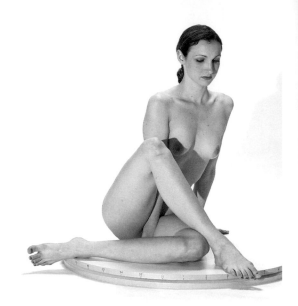
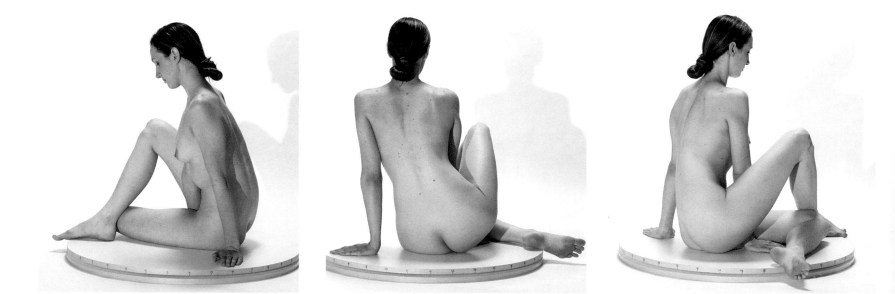

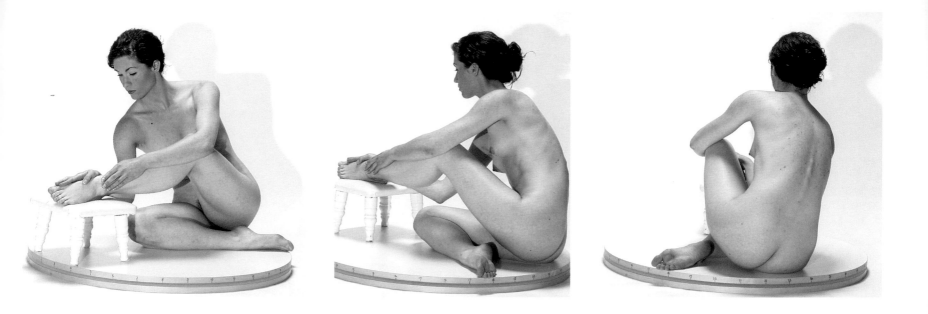

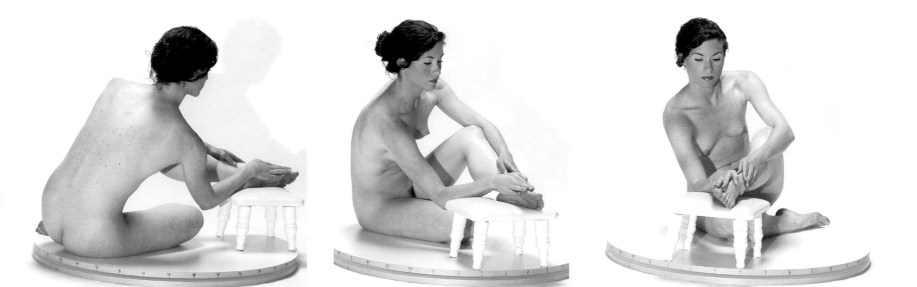

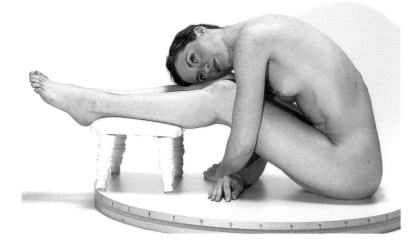

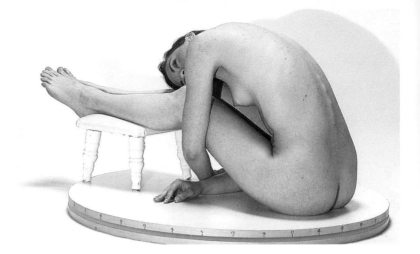

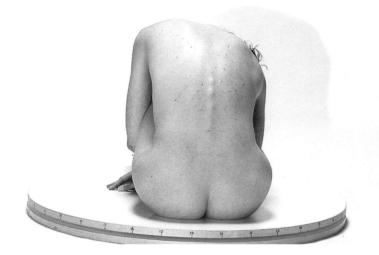

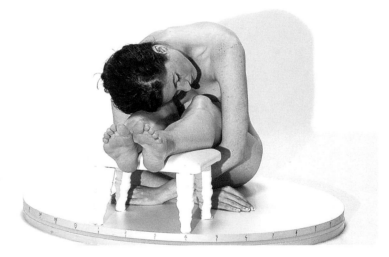

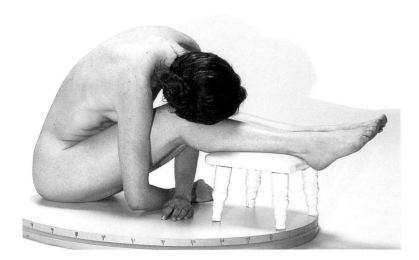

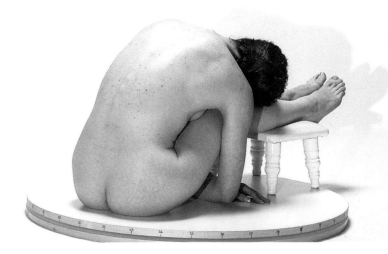

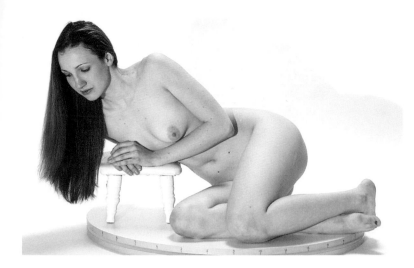

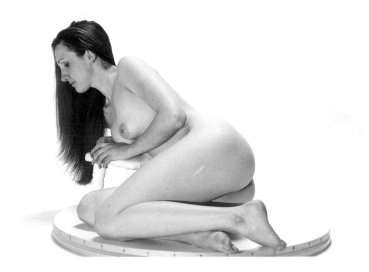

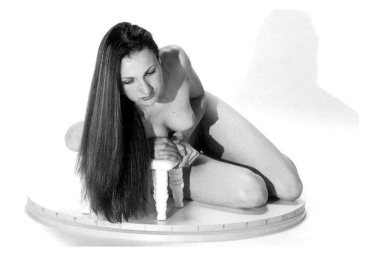

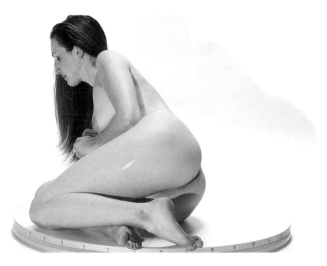

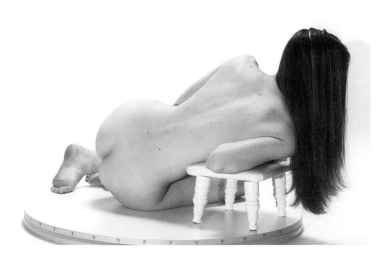

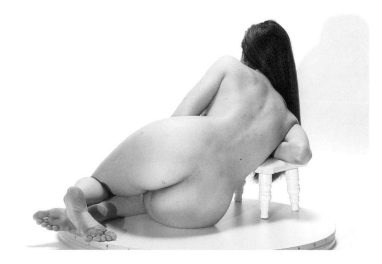

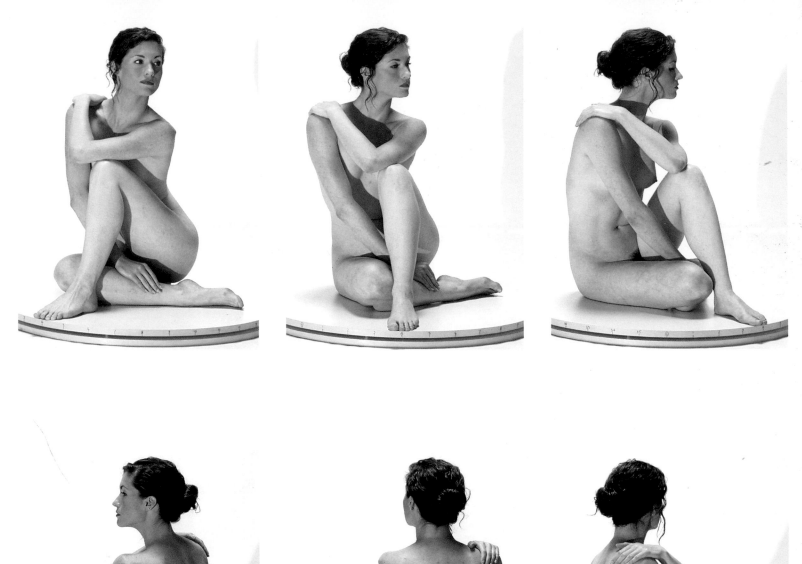

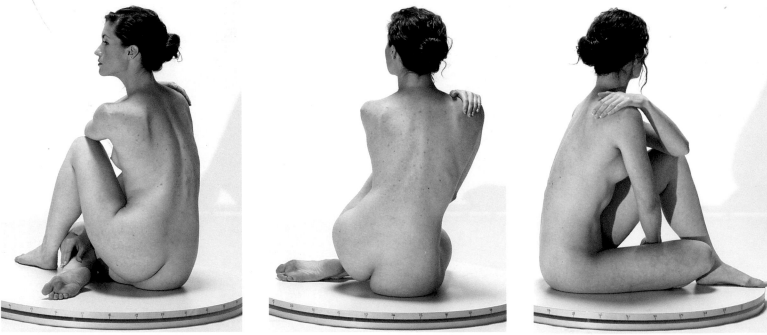

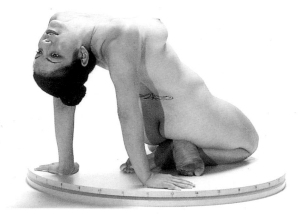
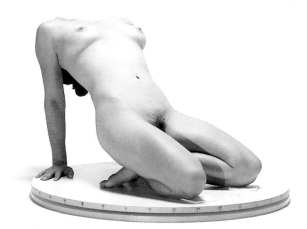
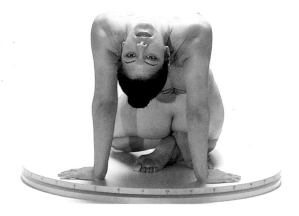
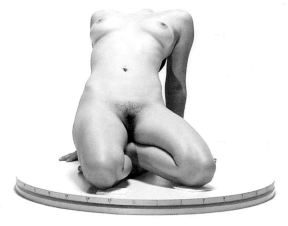
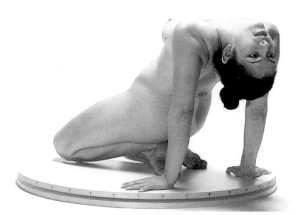
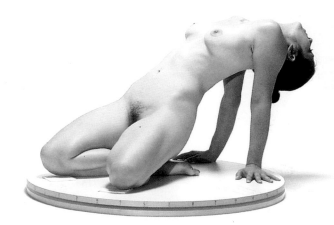

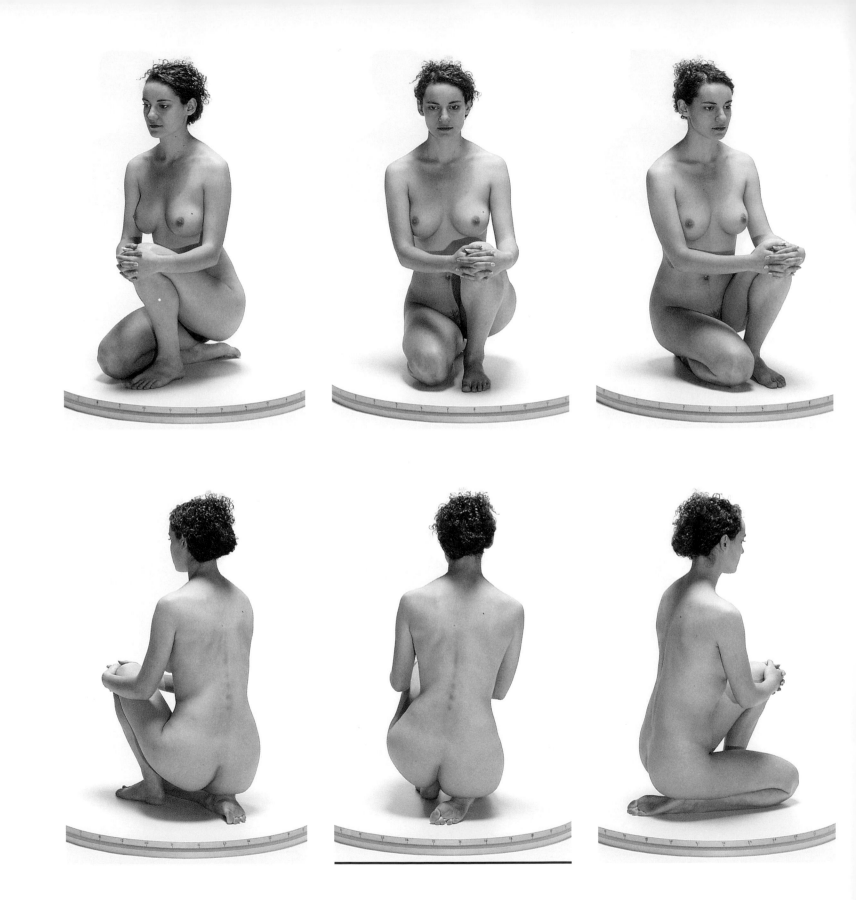

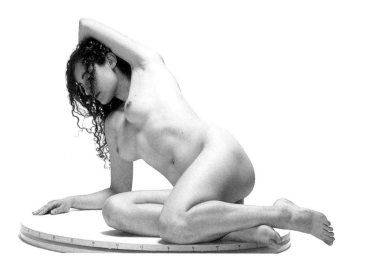

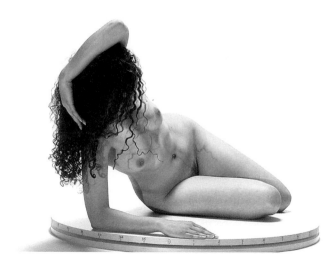

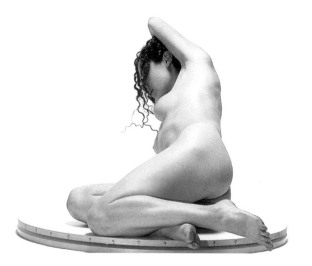

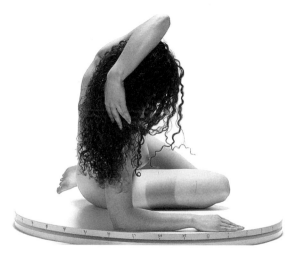

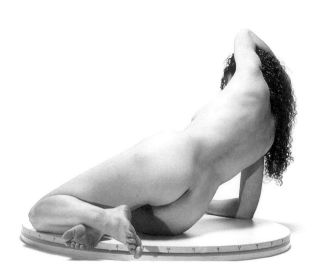

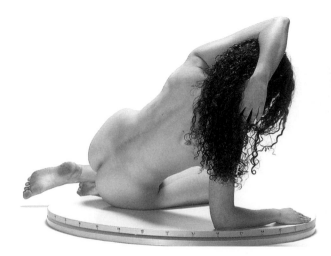

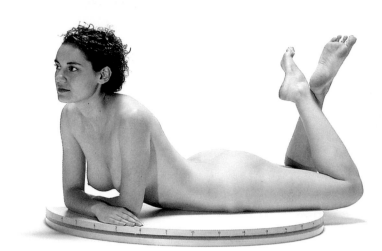
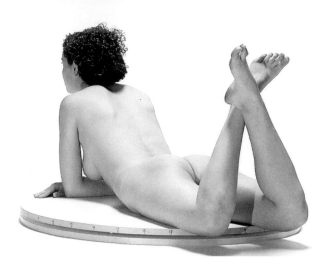
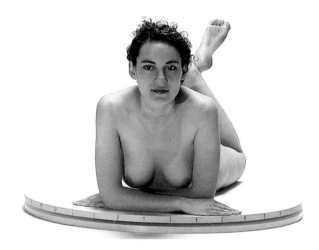
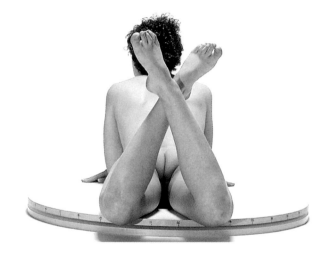
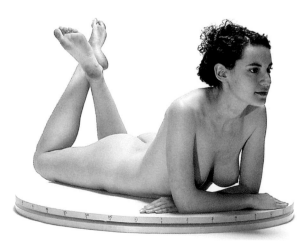
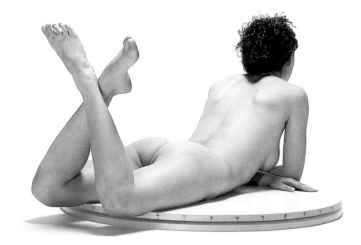

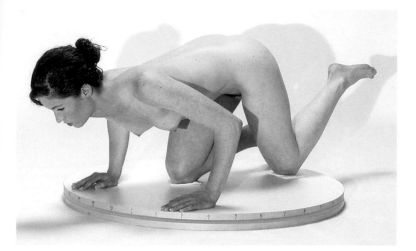
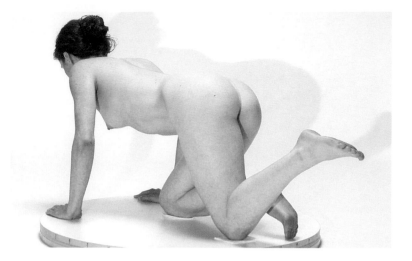
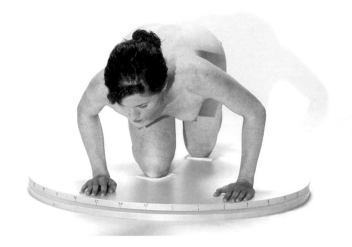
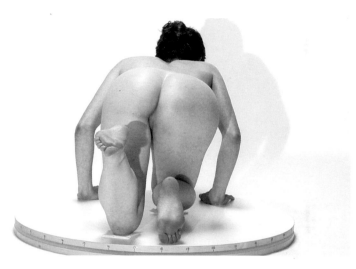
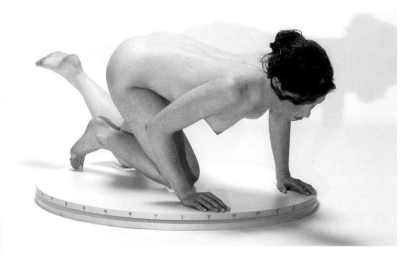
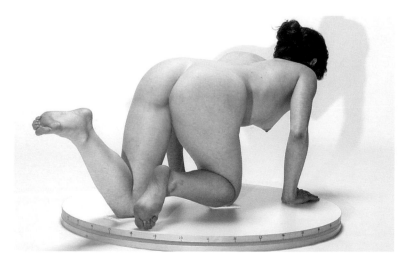

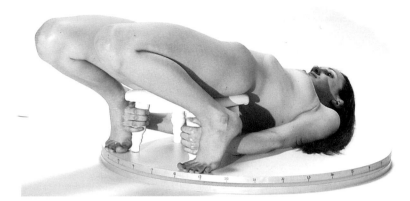
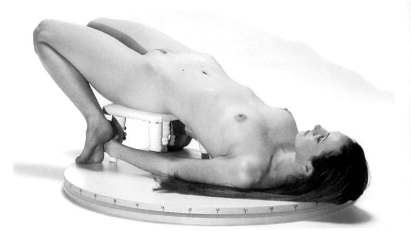
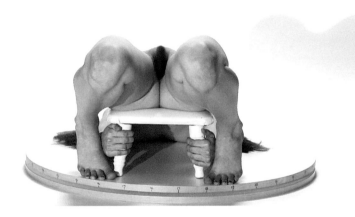
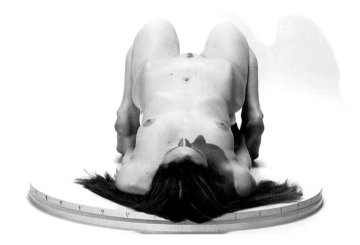
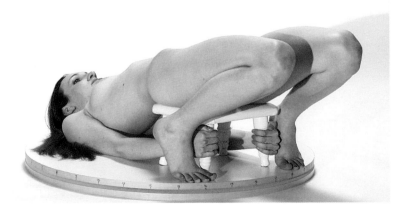
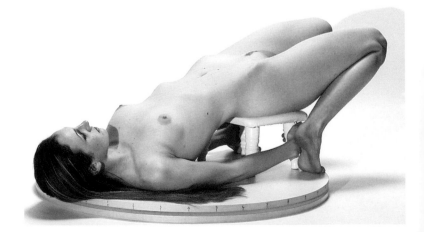

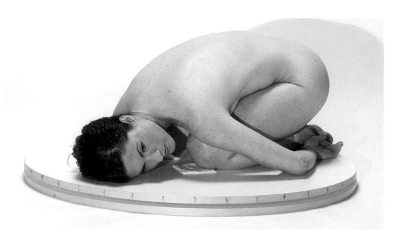
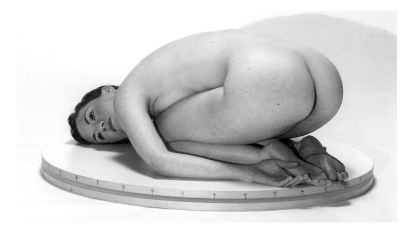
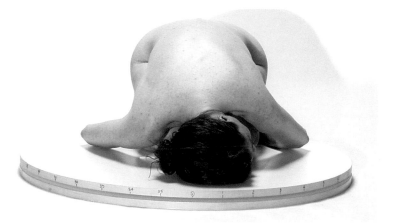
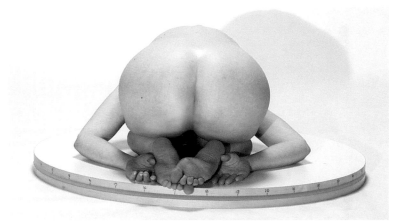
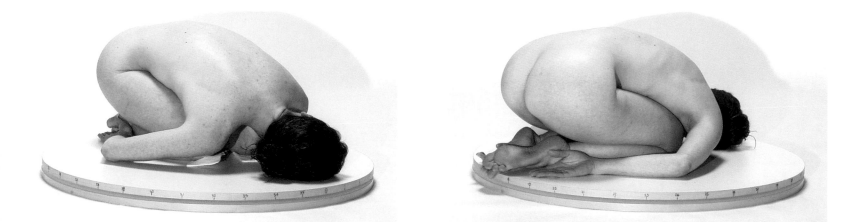

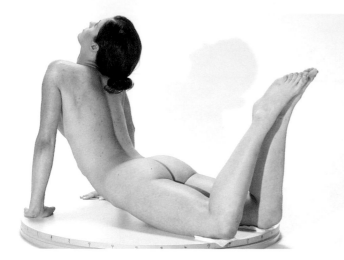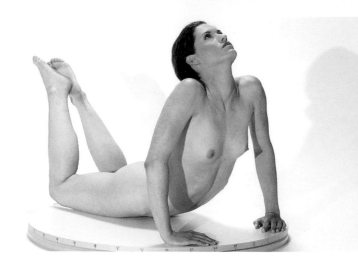

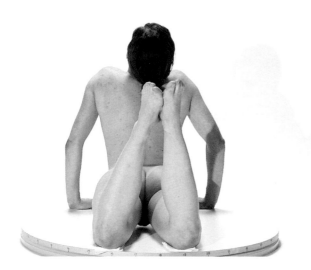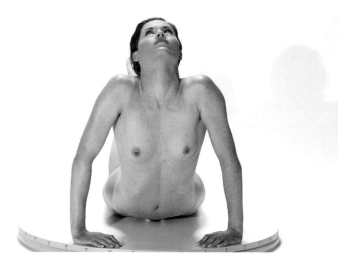

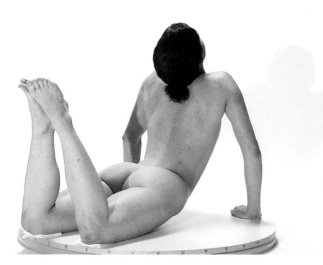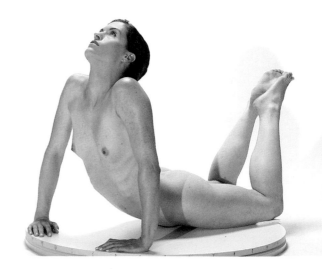

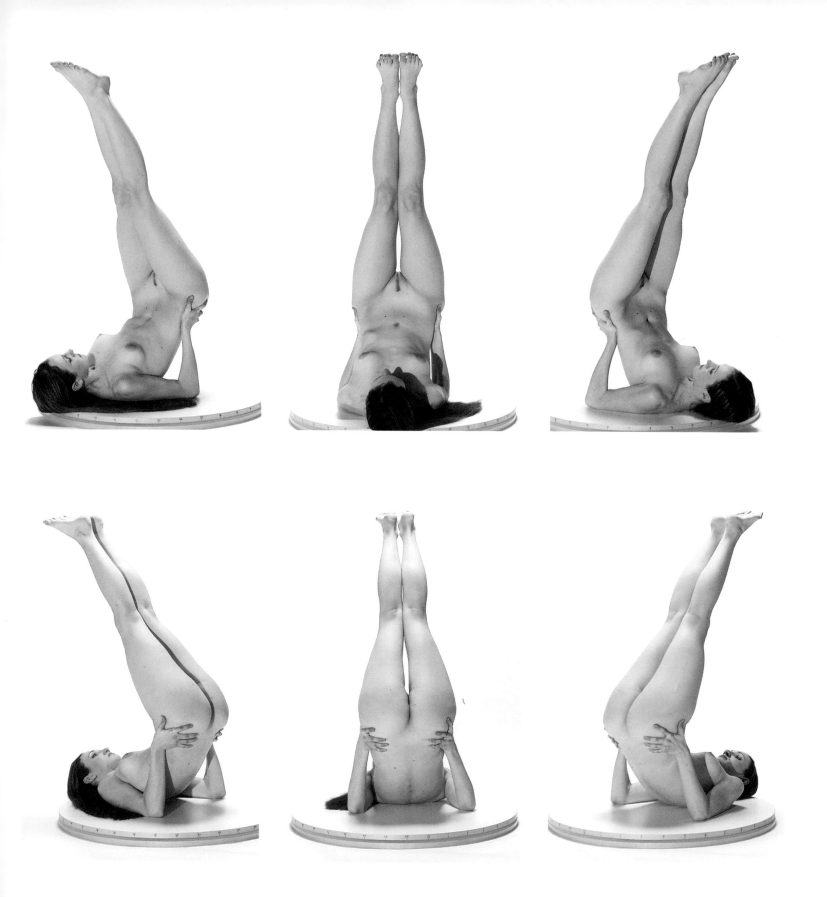

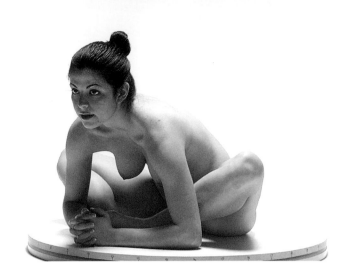
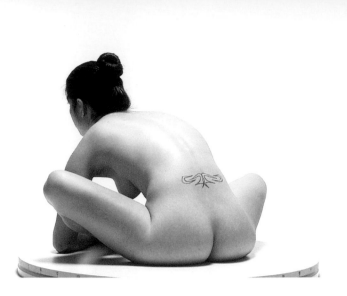
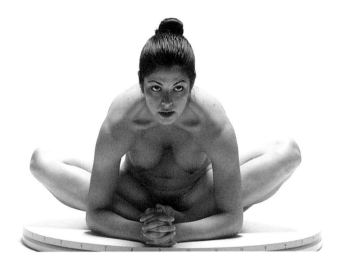
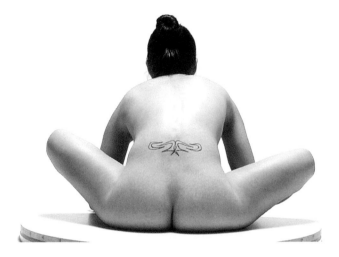
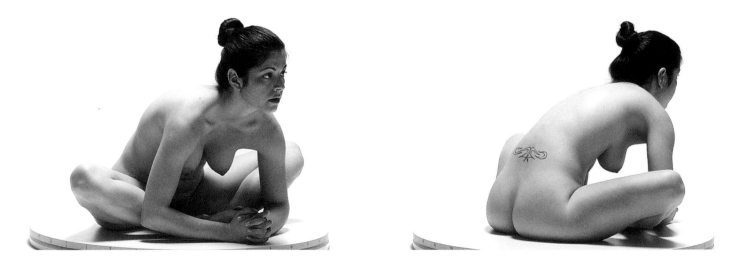

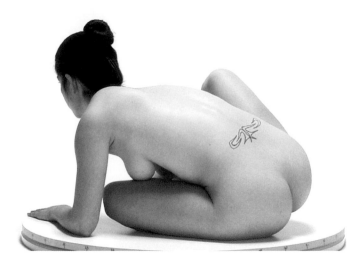
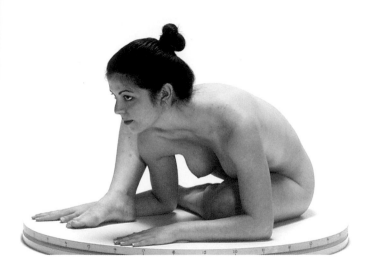
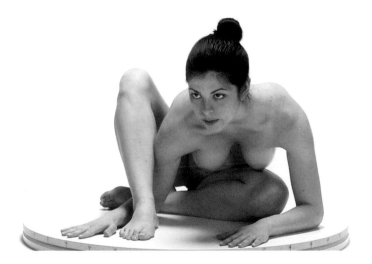
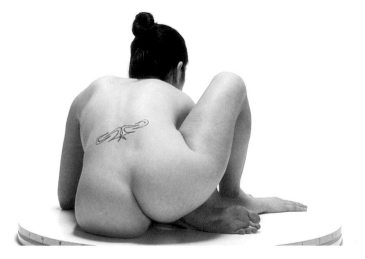
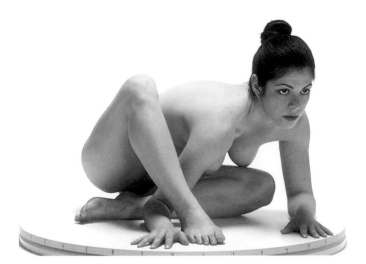
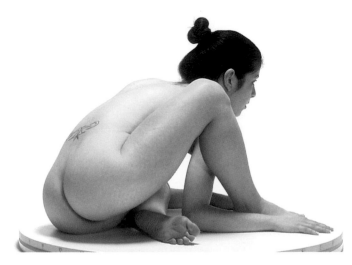

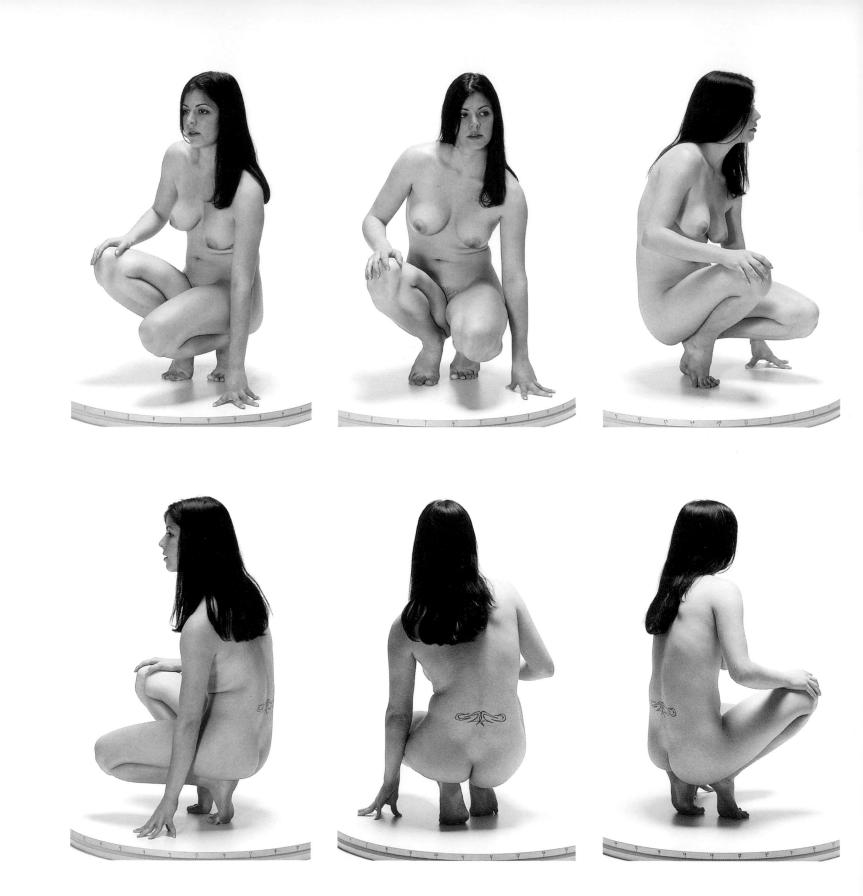

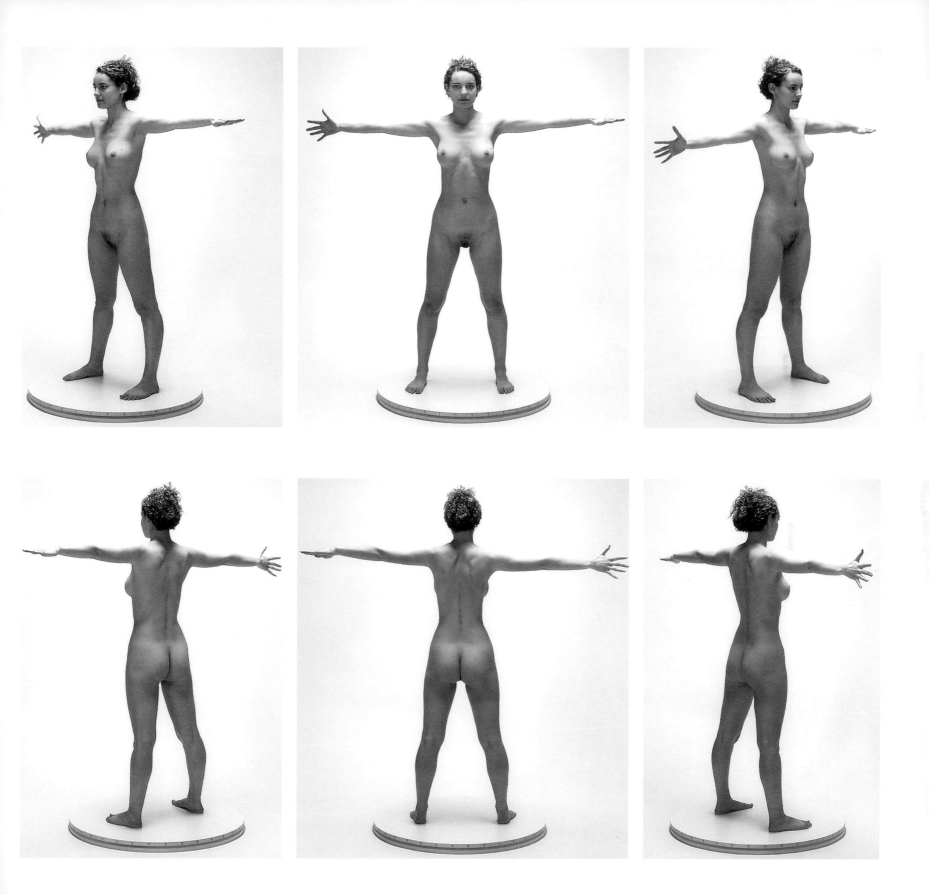

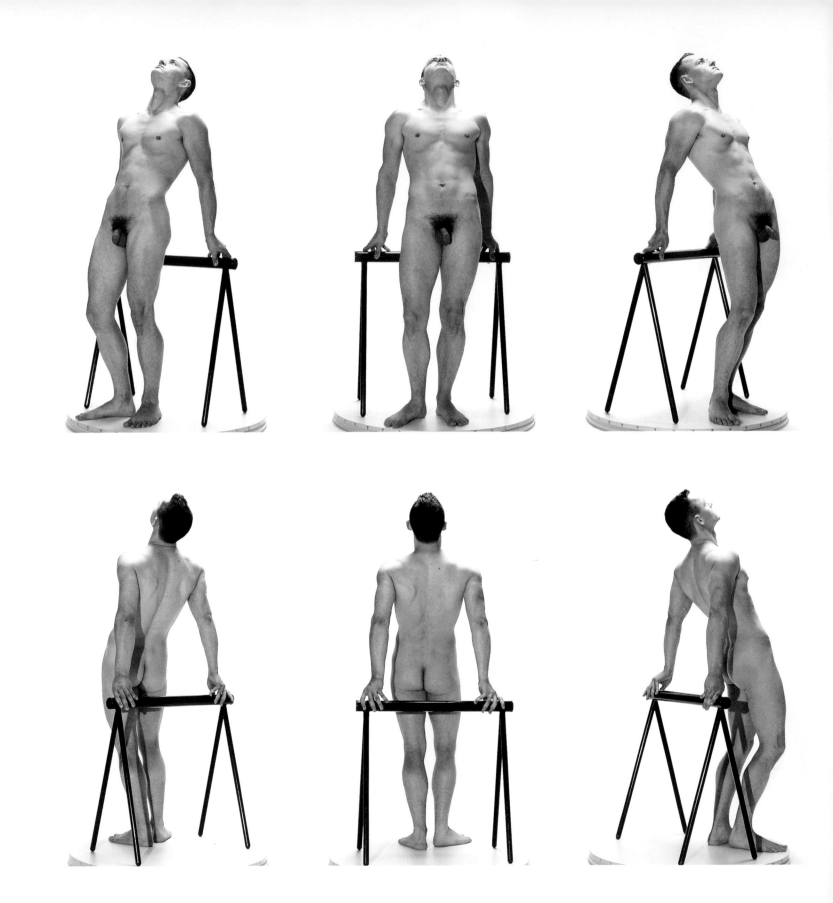

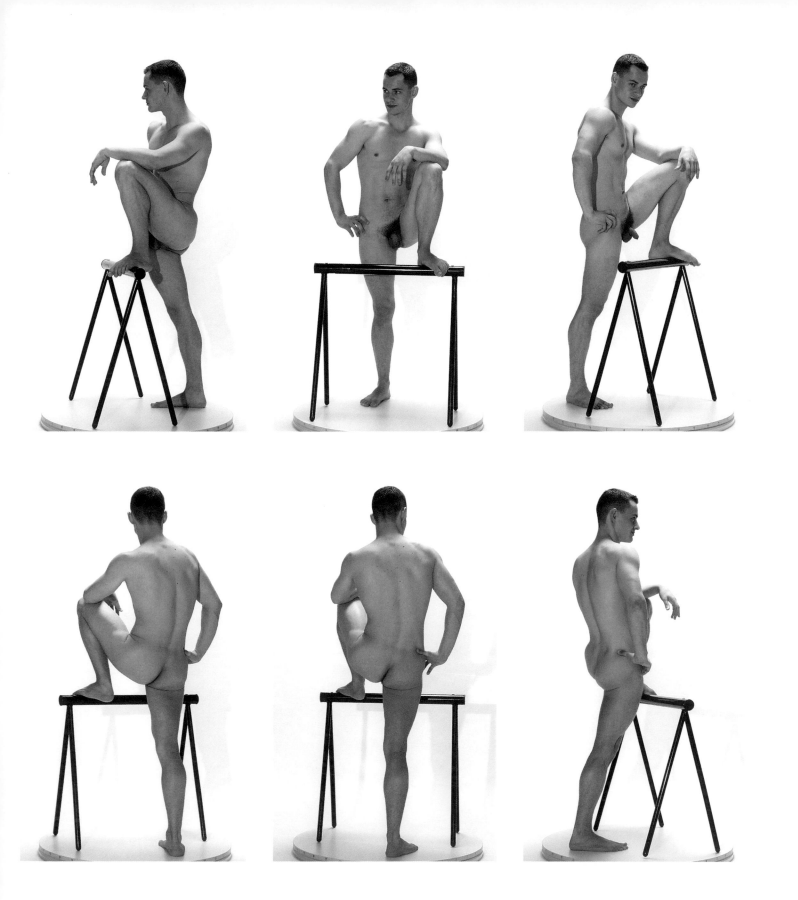

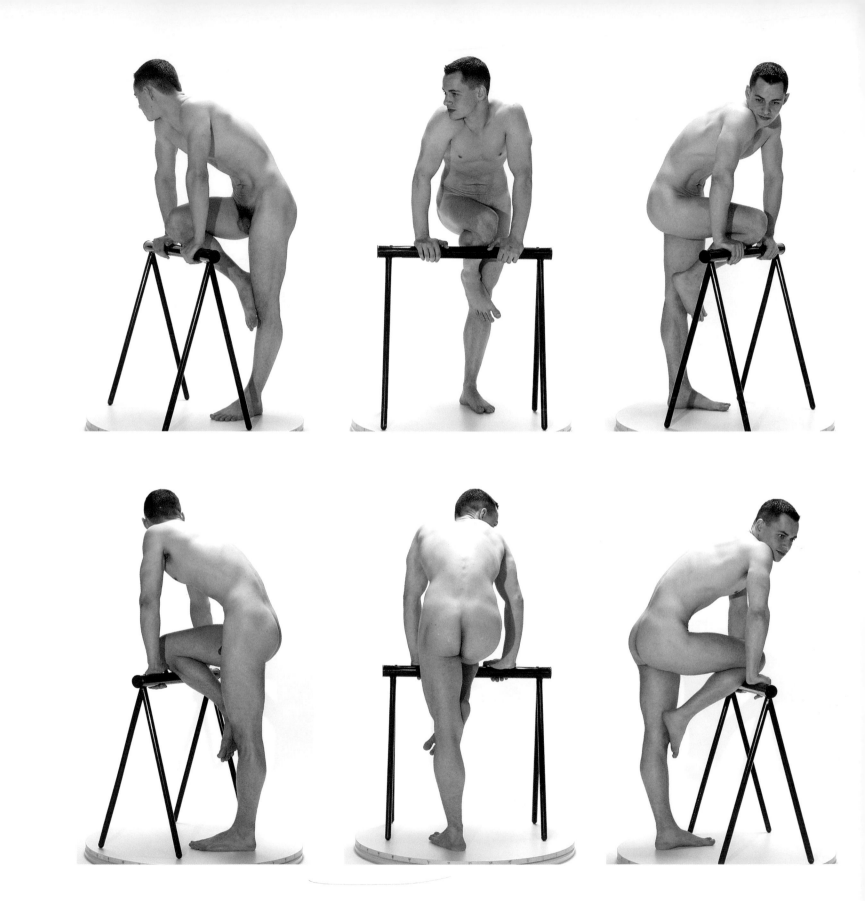

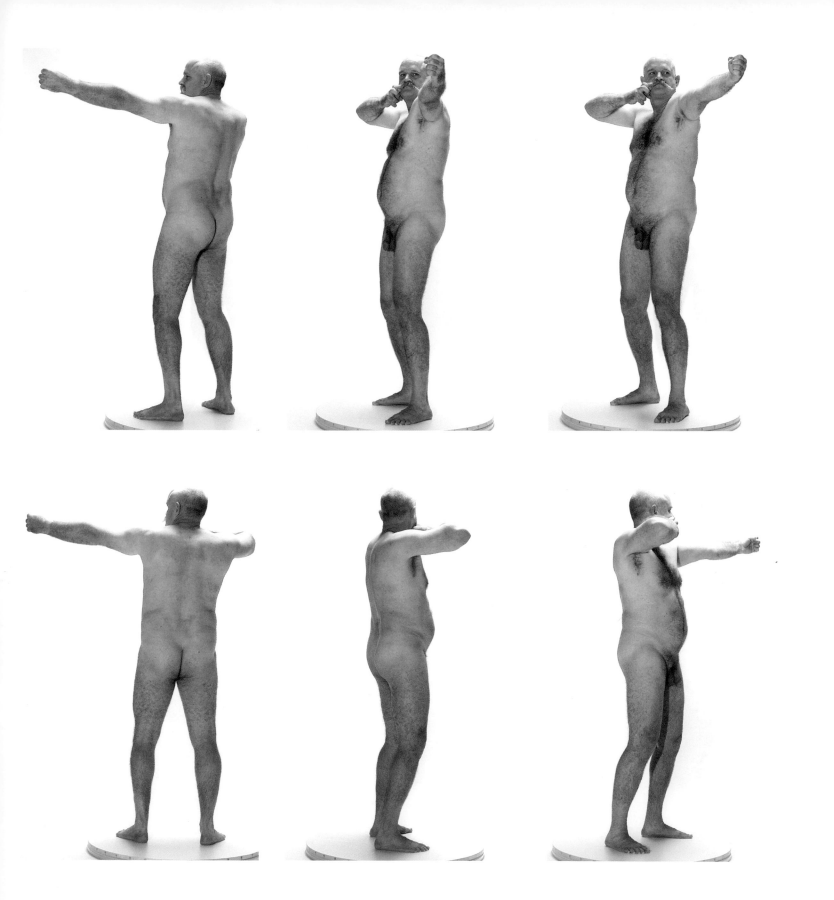

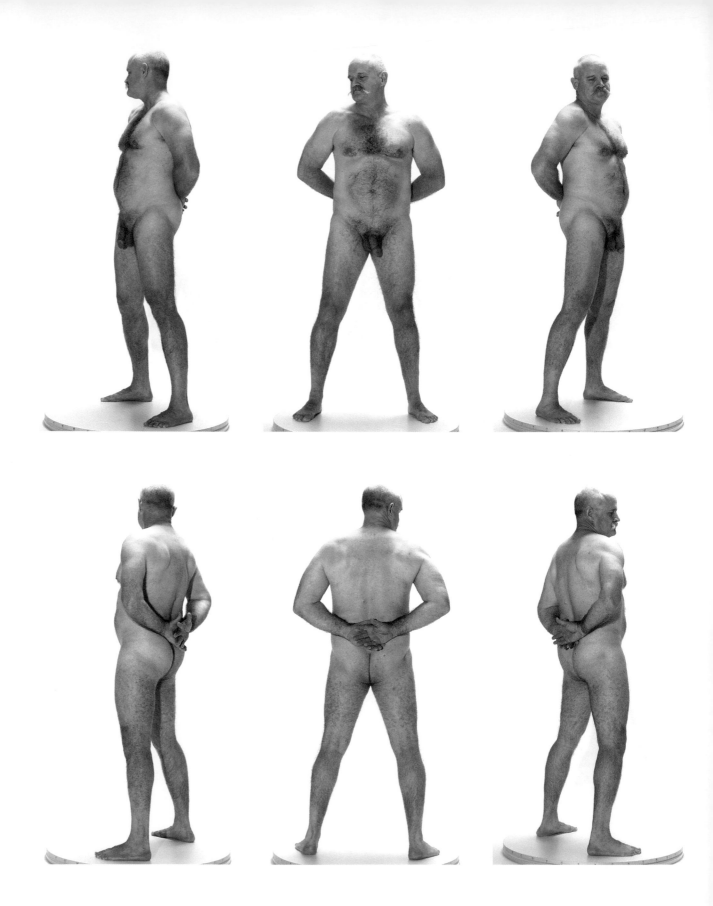

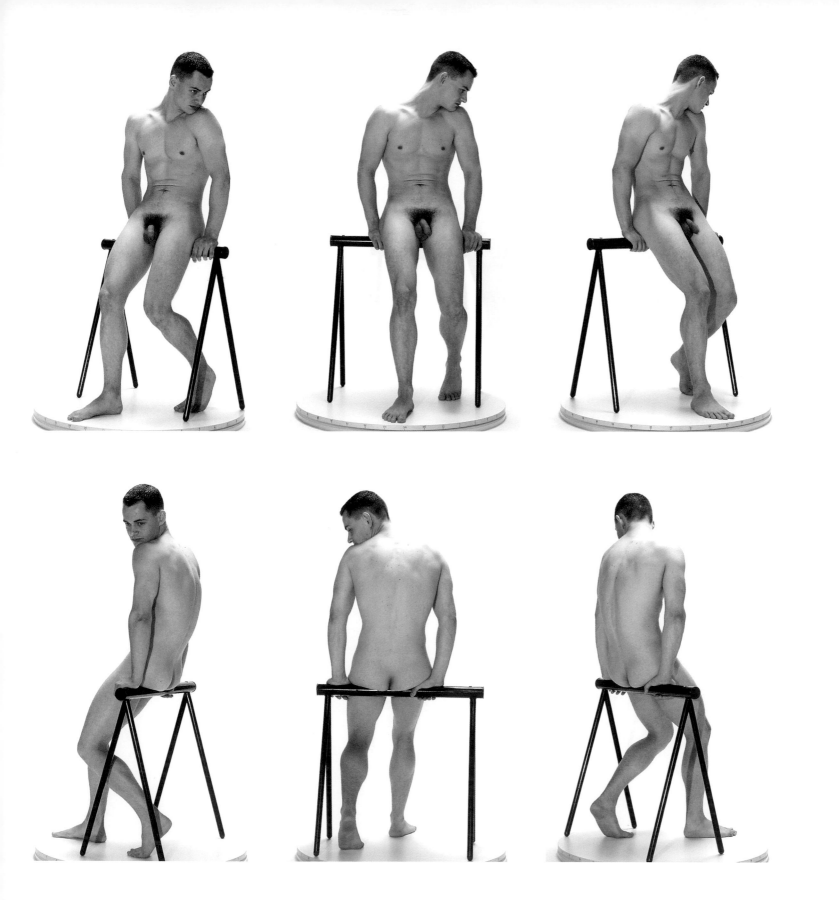

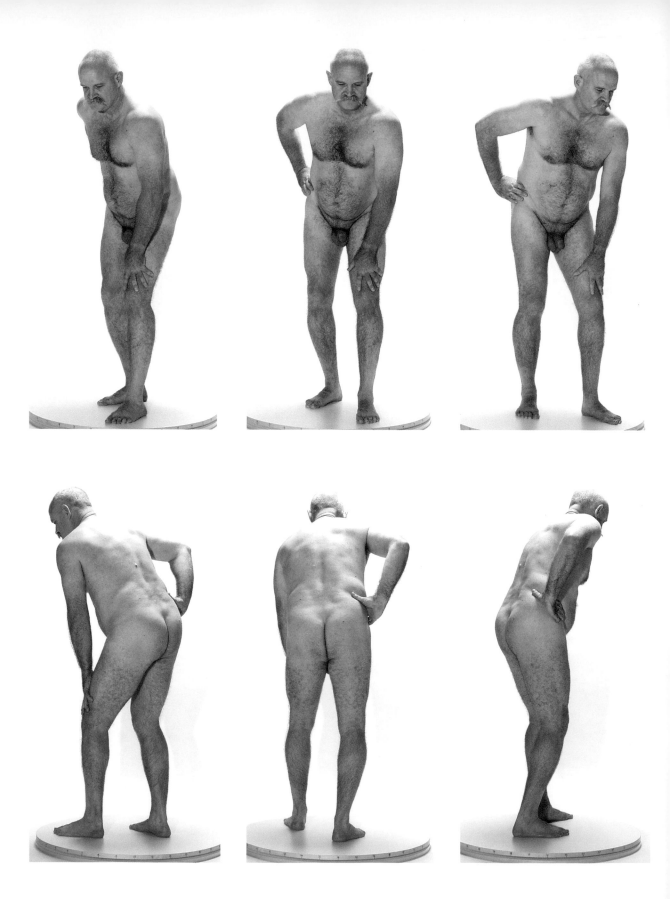

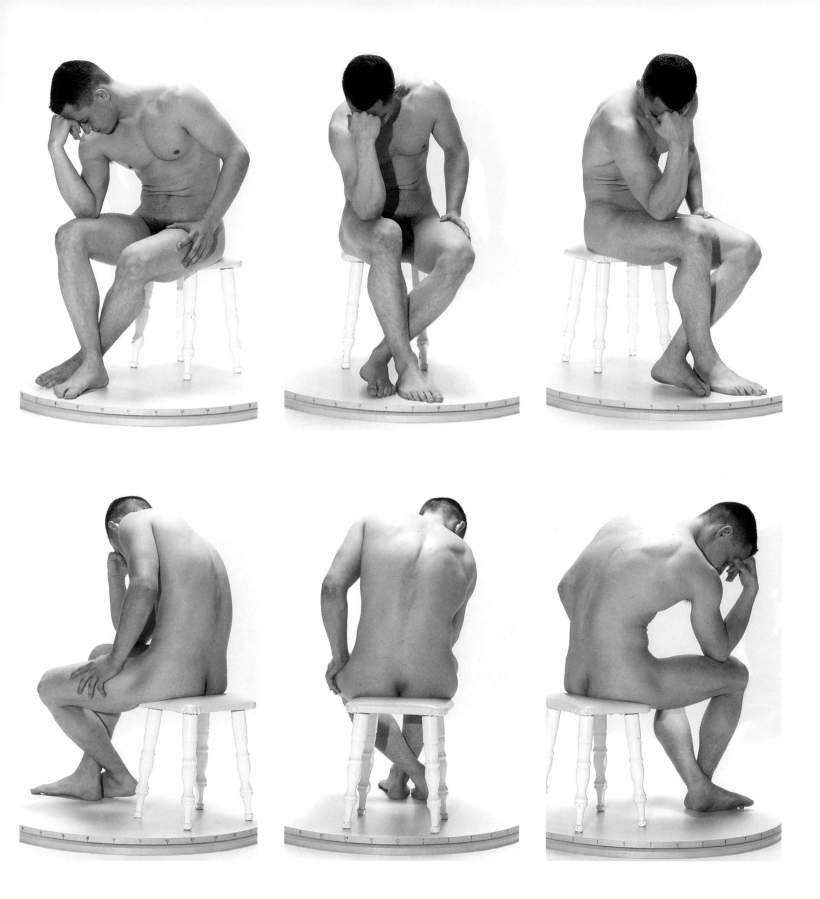

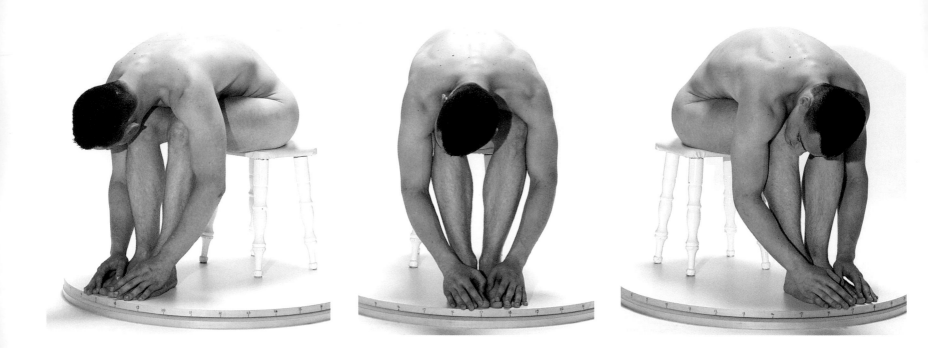

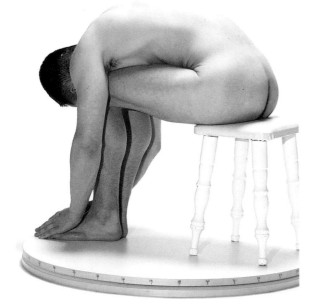
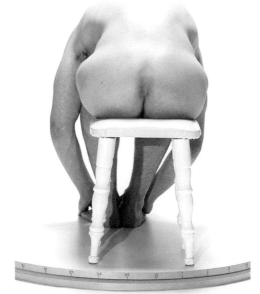
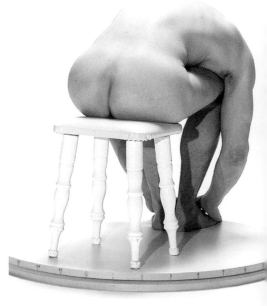

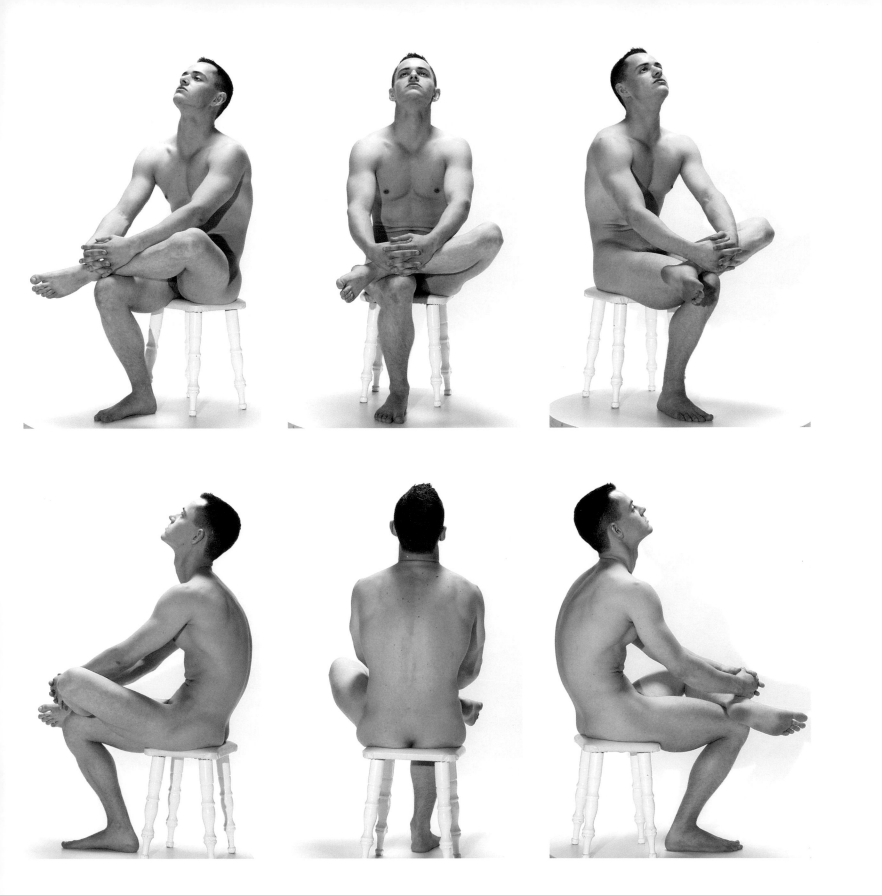

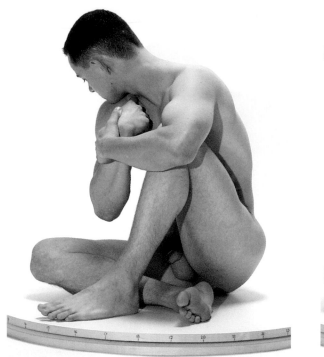
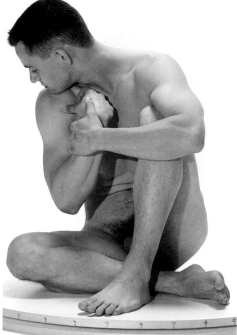
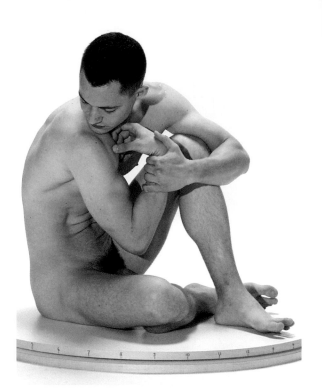
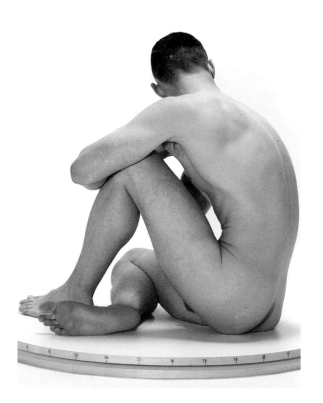
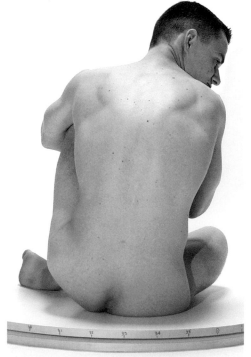
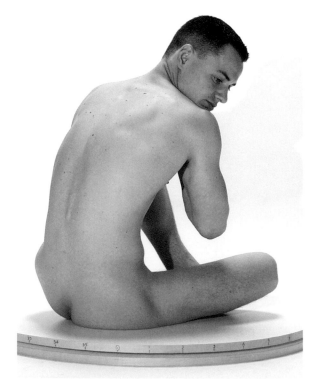

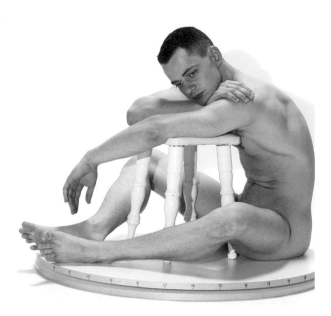
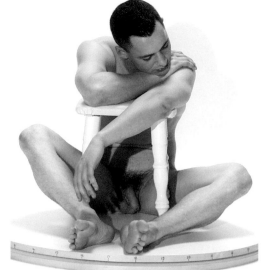
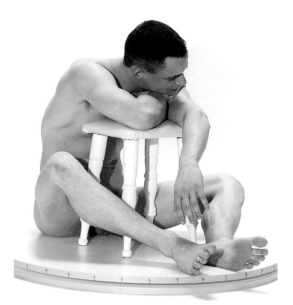
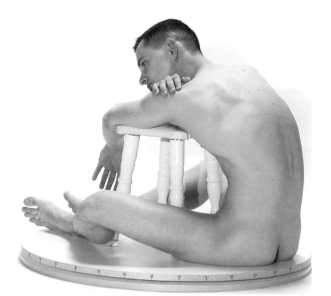
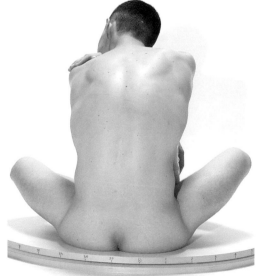
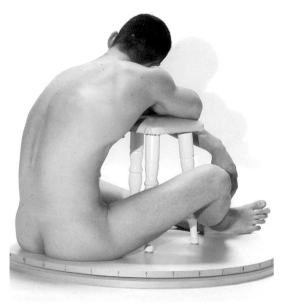

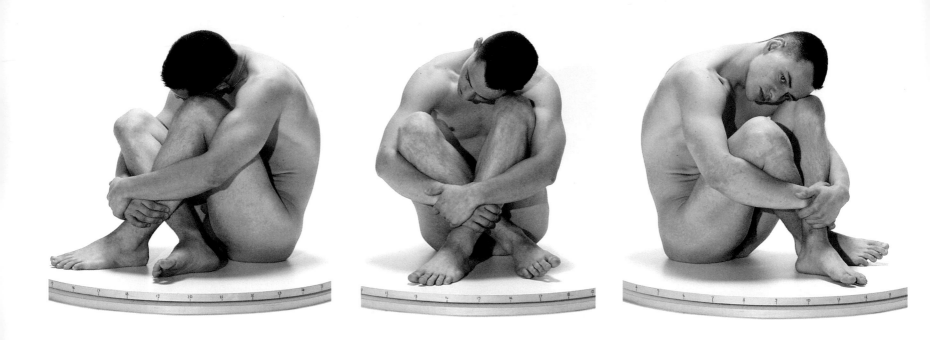

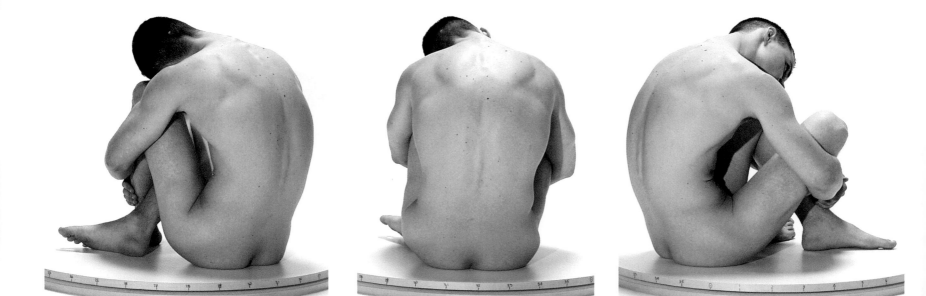

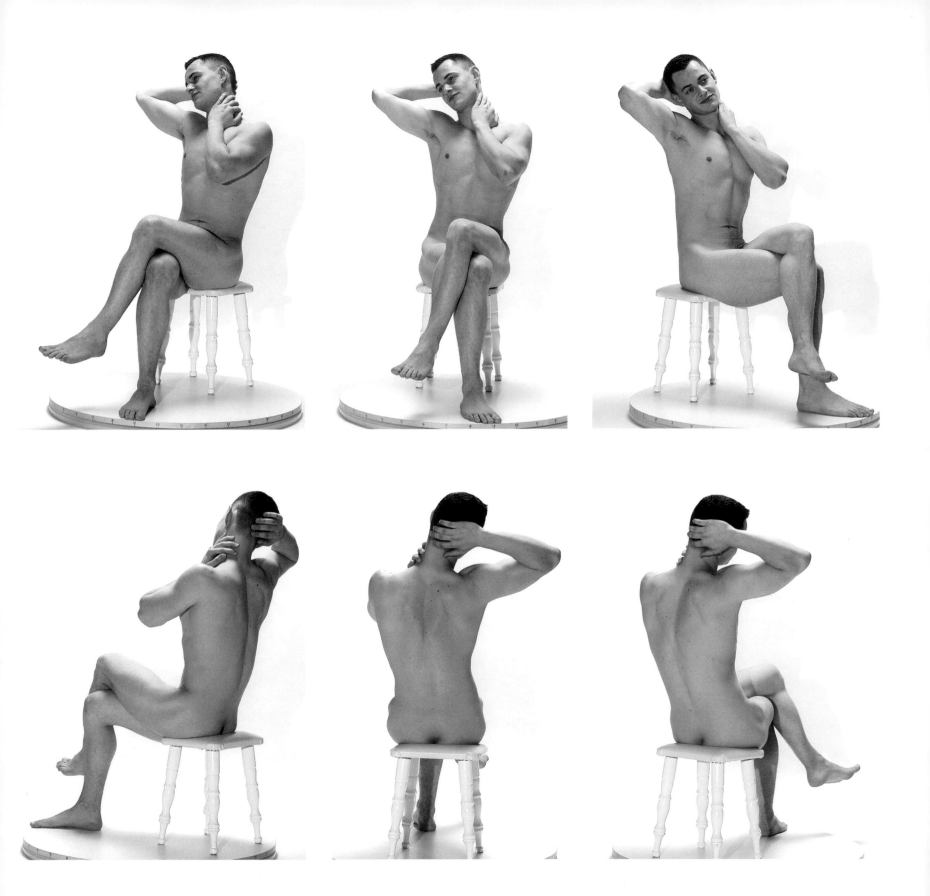

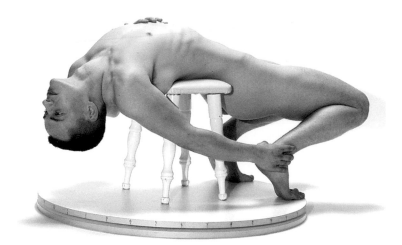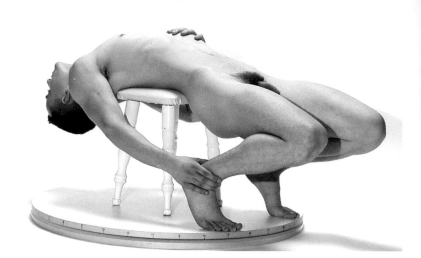

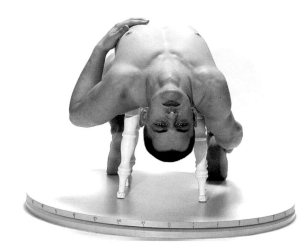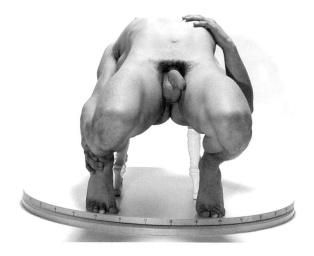

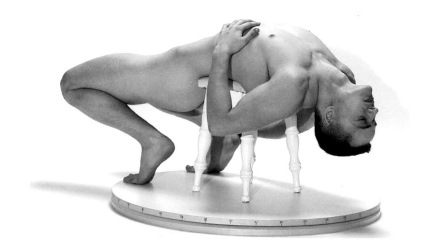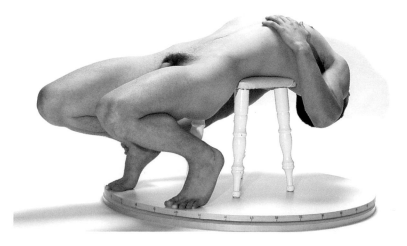

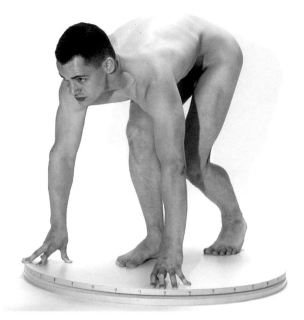
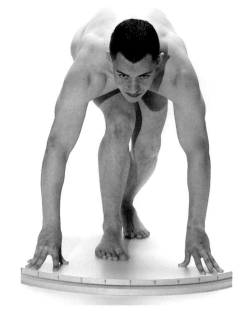
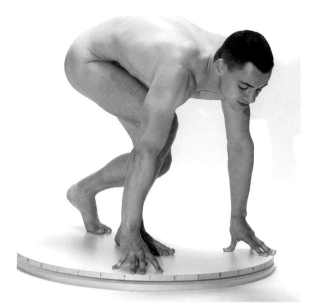
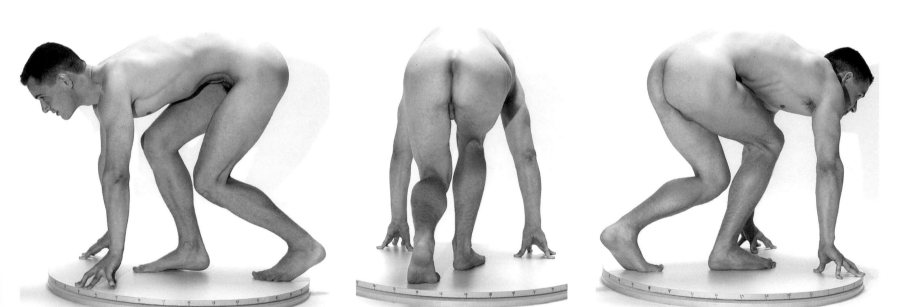

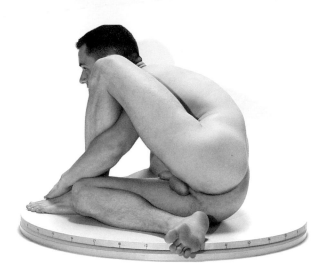

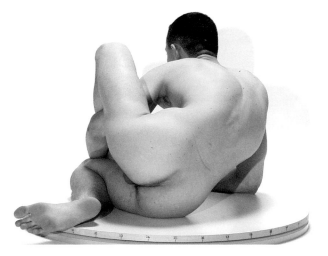

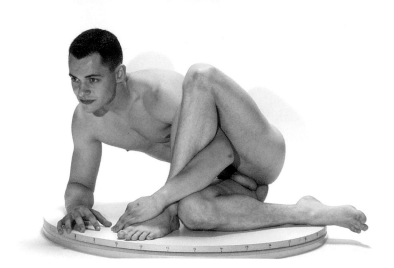

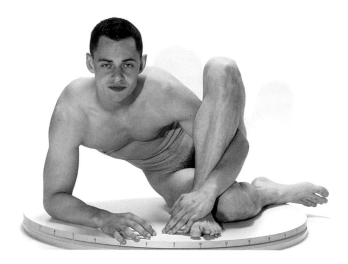

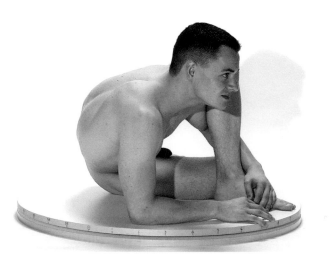

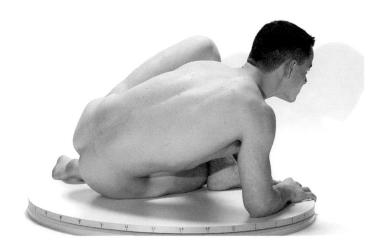

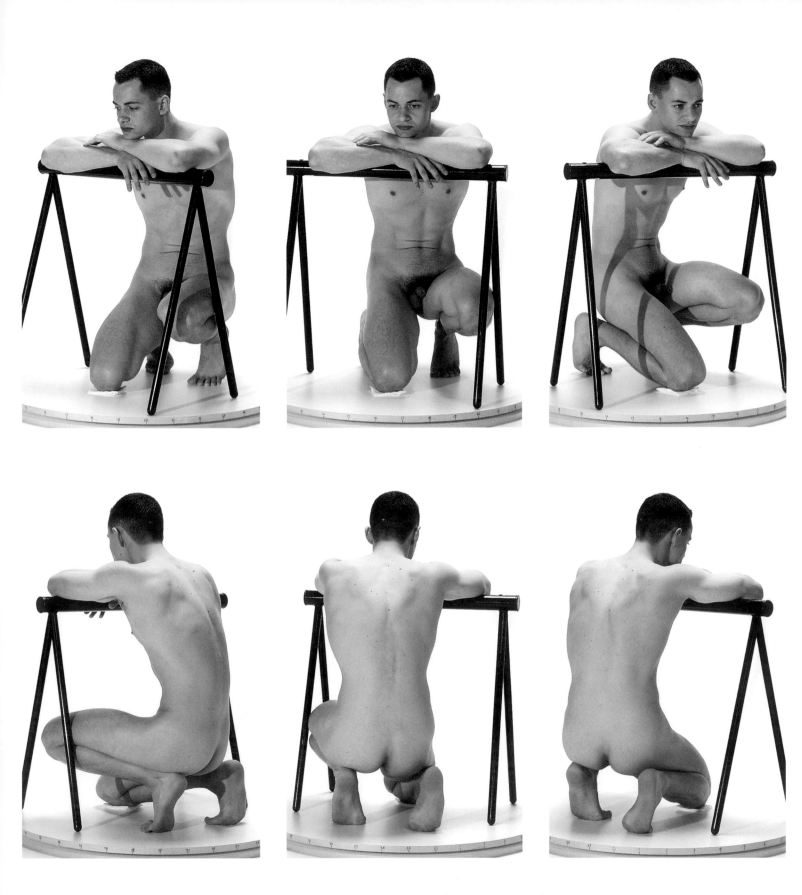

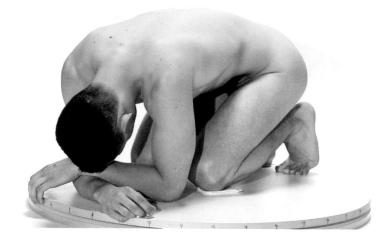

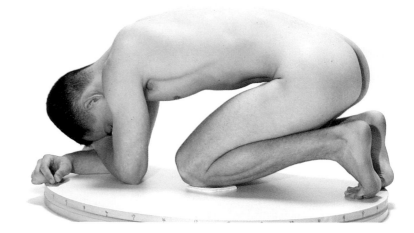

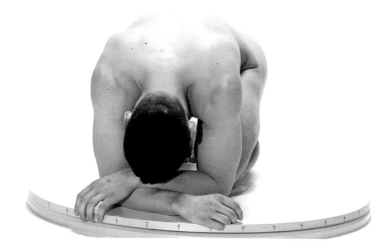

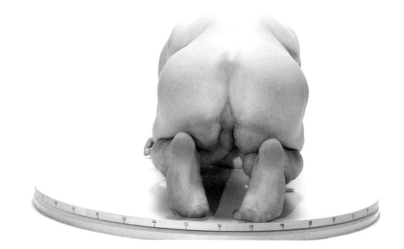

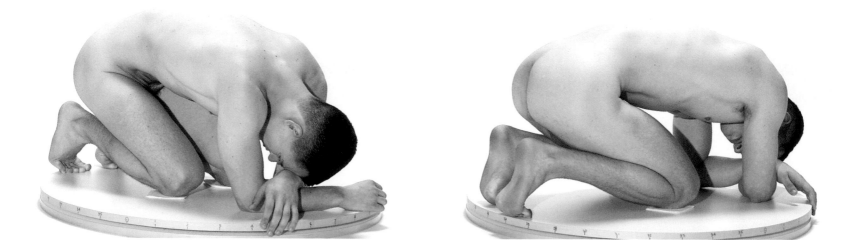

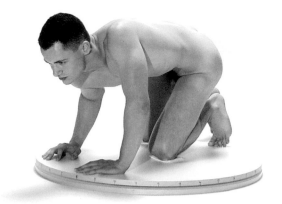

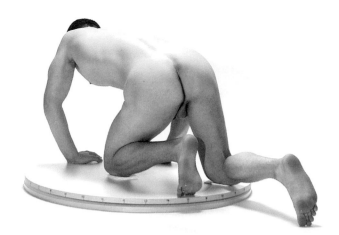

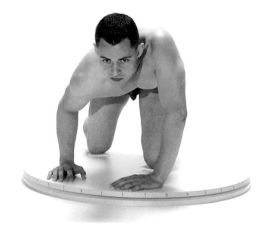

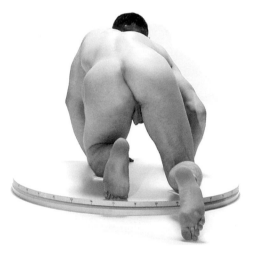

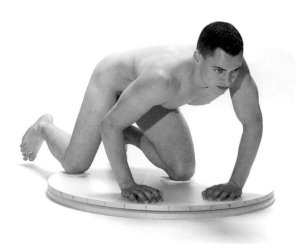

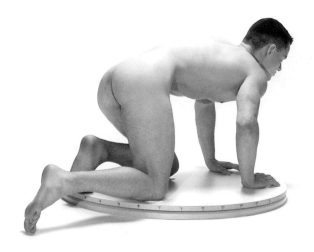

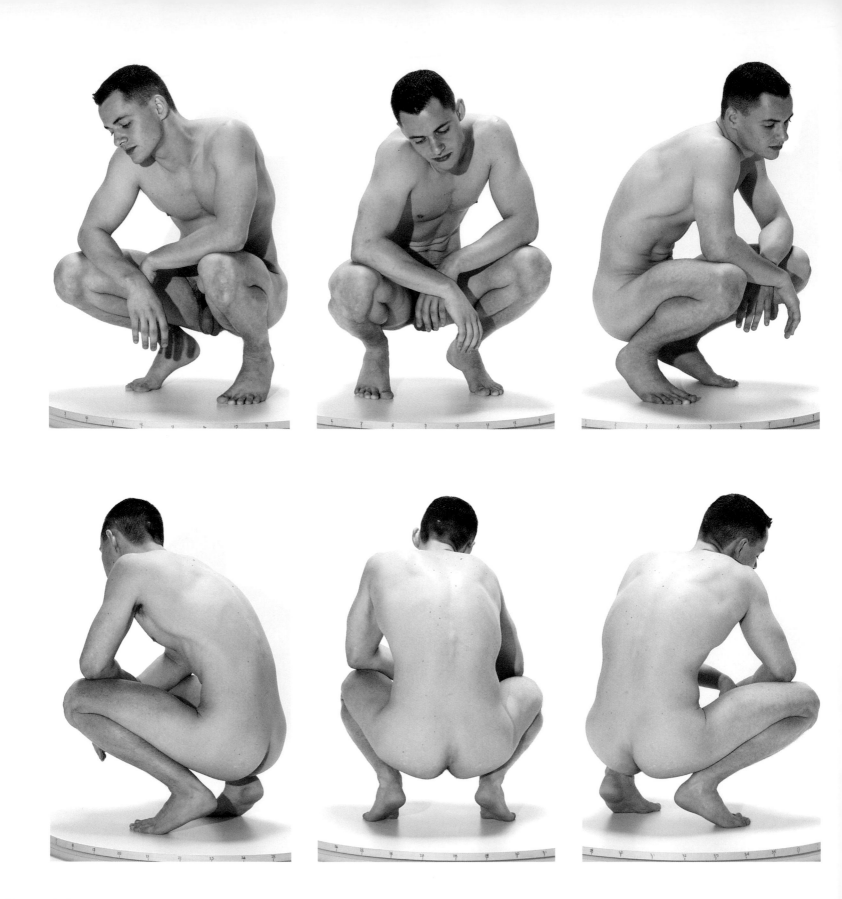

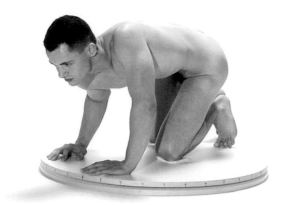
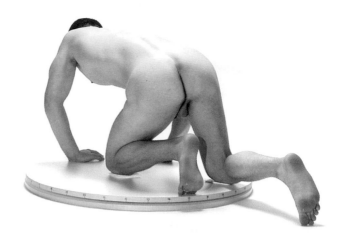
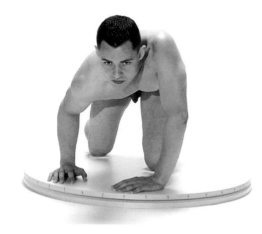
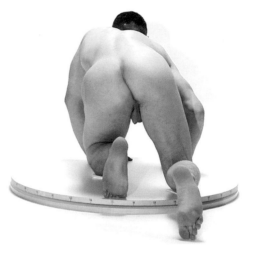
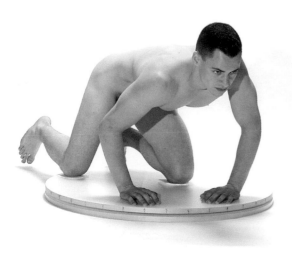
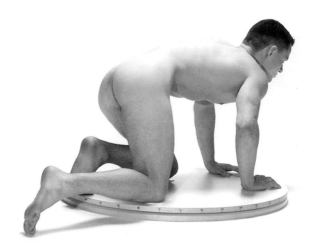

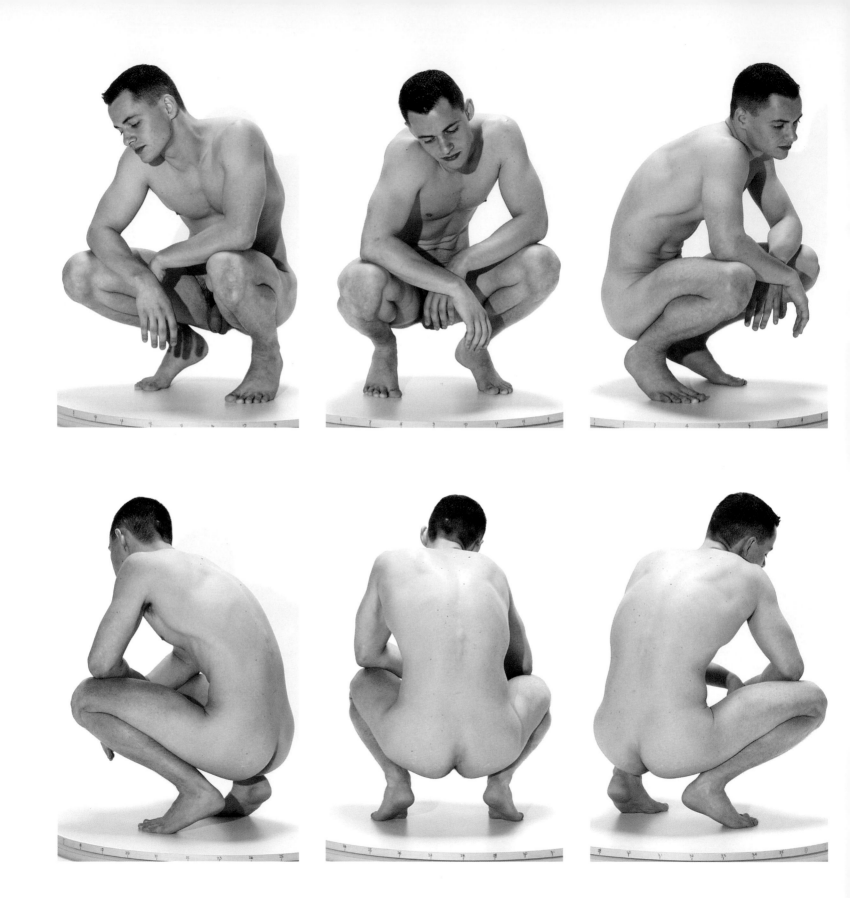

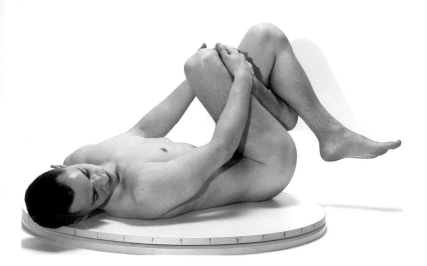
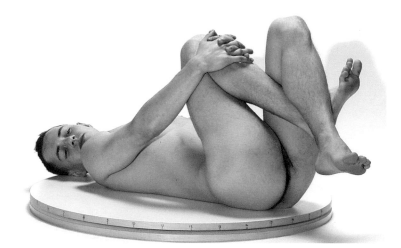
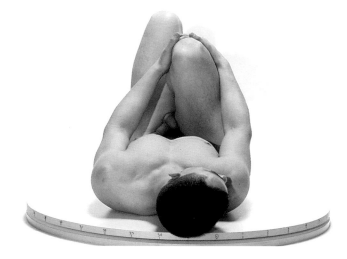
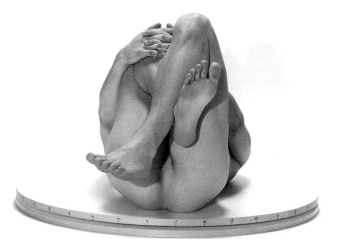
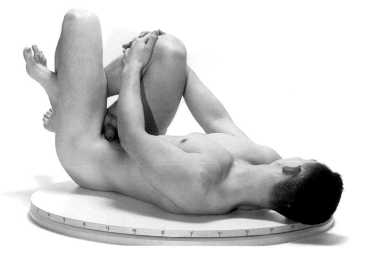
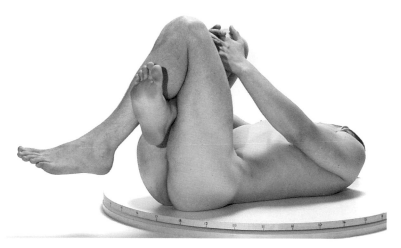

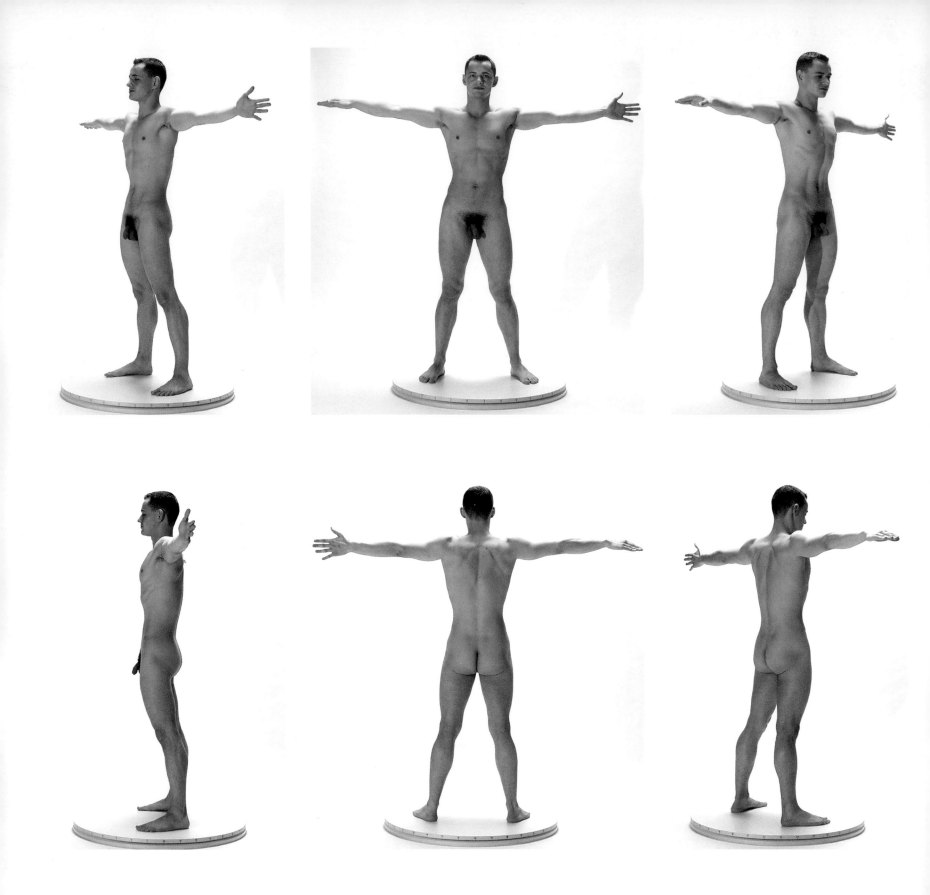

Acknowledgments

I would like to thank the following people and organizations for lending their time, support and resources:

All Things Art
Sid Buck
Dylan Byrd
The Asian Café
Craig Bergsgaard
Ted Culp
Salam Dahbour
Alain Debrabant
Yulia Eyman
Greg Gissler
Jerri Graham
Natasha Grandon
Timb Hamilton
Iavor Ivanov
Dona Jones
Angelique Kithos
Mounir Murad
Candace Nirvana
Ross Pierce
The Punkin
Sarit Schneider
Al and Beverly Solomon
The Washington School of Photography
John Wilson
Imaging Zone

Beth, whose bravery is an inspiration to me.

Greg and Missy, my better thirds.

Last but not least, all the artists who invested in Virtual Pose 1 and 2; I especially would like to thank all those who took the time to express their opinions and whose valuable feedback played a vital role in shaping Virtual Pose 3.

Lastly, I dedicate this project to the pursuit of art, a power vast enough to embrace the heavens, yet humble enough to dwell within the heart.